The Little Girl's Little Book of

Art

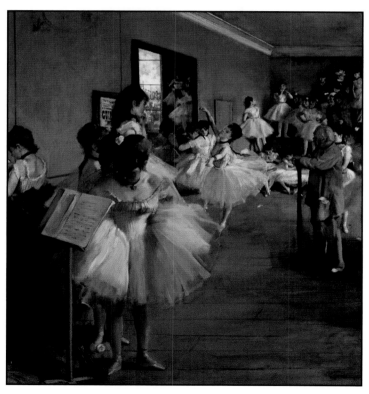

Bellagio Press

Previous page:
The Dance Class
Edgar Degas
1874
Oil on canvas
83.5 x 77.2 cm
The Metropolitan
Museum of Art,
New York, New York
Opposite page:
Mother and Child
Mary Cassatt
1890
Oil on canvas
90.2 x 64.5 cm
Wichita Art Museum,
Wichita, Kansas
This page:
*The Daughters of
Edward Darley Boit*
John Singer Sargent
1882
Oil on canvas
221.93 x 222.57 cm
Museum of Fine Arts Boston,
Boston, Massachusetts

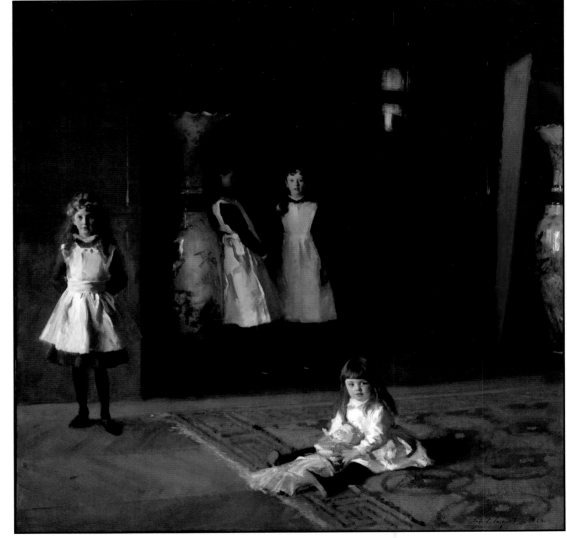

The Little Girl's Little Book of
Art

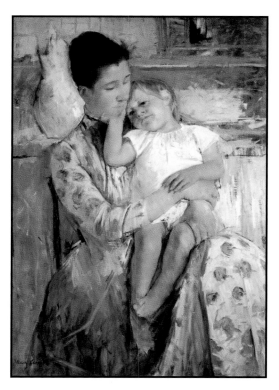

Bellagio Press

Kathryn Dixon

Published by Bellagio Press 2014
5501 Kincross Lane
Charlotte, North Carolina, USA
28277

www.bellagiopress.com

ISBN 978-1-62732-013-9

Printed in China

1 2 3 4 5 18 17 16 15 14

To my loving husband

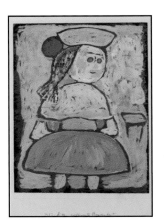

*Costumed
Peasant Girl*
Paul Klee
1937
Gouache
on paper
28 x 21.6 cm
Private Collection

Table of Contents

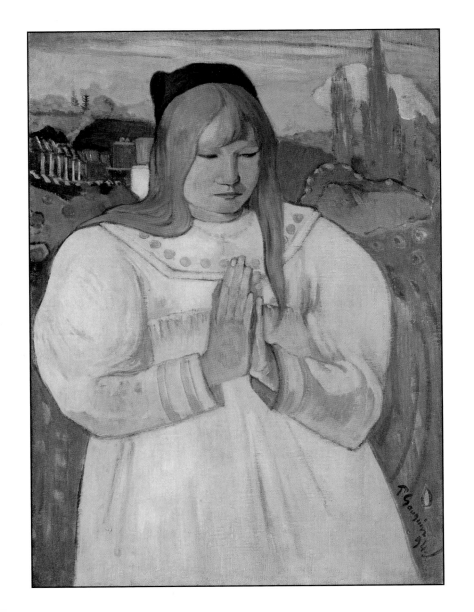

Young Christian Girl
1894
Oil on canvas
65.2 x 46.7 cm
Sterling and Francine Clark Art Institute,
Williamstown, Massachusetts

A Special Note to Readers

A story lies behind every picture that an artist creates. As you turn the pages of this book you will read about the stories behind many of the pictures that you see—but please do not stop there. I hope you will let your imagination weave your own stories about each picture, so that every picture will have a special meaning just for you. When I was six or seven years old my Aunt Saleta and Uncle Joe gave me a print of Renoir's *A Girl with a Watering Can* (the big picture on the front of this book). My mother framed it and hung it on the wall of my bedroom. I would spend hours immersed in that picture, wondering about where that little girl was going with her watering can. Was it full or empty? Why was she wearing such a pretty dress in the garden? I wouldn't even have worn a dress that fancy to go to church! Where did the path she was on lead? Little did I know that Renoir (the artist who painted the picture) was one of the great Impressionist painters. I did know, however, that the painting was done "a long time ago" and yet it enthralled me as much or more than the Vogue pattern books at the local fabric store. A little girl in rural South Carolina, I was fascinated with another little girl who lived across the Atlantic Ocean in France many years earlier. I was also fascinated with how a blank piece of canvas or paper or marble is transformed by the artist into a finished work. It seemed like a miracle. I scrutinized the little girl and the garden around her for clues as to the way she was created. Could I do that one day? How did the artist make a little girl out of a paintbrush and paint? How did each separate brush stroke or daub combine to make a realistic picture? My curiosity was piqued, not only about the little girl that Renoir painted, but by the creative process. That one picture—a lovely and loving gift—opened my eyes to a bigger world than I would otherwise have known as a child. My picture, albeit in a different frame today than when I was a child, still takes pride of place in my home. And everytime I walk past that litte girl with a watering can she catches my eye. I still feel as great an affection for her as I did when I first met her. I hope this little book will encourage you, young reader, to dream and to marvel and to appreciate not only the act of creativity but a new way of seeing the world.

Leonardo da Vinci

1452 to 1519

Italian, lived in the Republic of Florence (Italy)

Interesting Fact: *Leonardo da Vinci designed a flying machine 400 years before the Wright Brothers flew the first airplane at Kitty Hawk, North Carolina.*

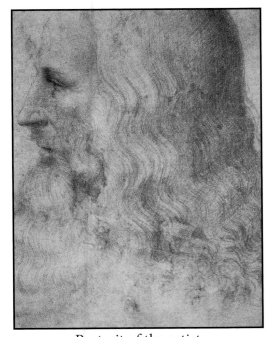

Portrait of the artist
after the age of 58
drawn by Francesco Melzi

When Leonardo da Vinci was just 14 years old, he left the home of his father to live with and to learn from an artist named Andrea del Verrocchio (his last name rhymes with Pinocchio, the wooden boy whose nose would grow longer every time he told a lie, and his first name is Italian for Andrew even though in English it looks like a girl's name). After six years of studies, da Vinci started his own workshop. Not only did he love to paint and draw, he was also quite fond of science and mathematics. Drawing was a tool that he used to record nature and his inventions. Leonardo da Vinci is known as a Renaissance Man, someone who is interested in and knows a lot about many things. Today, a girl can be a Renaissance Man too if she learns a lot about a lot of different things. *Mona Lisa* is the most famous portrait (a picture of a person) of all time. She is known for her smile. Another masterpiece (a great work) of da Vinci is *The Lady with the Ermine*. The lady, however, is a teenager named Cecilia. The ermine that she holds has sharp teeth and claws and its fur changes color with the seasons, becoming white in winter. What season—winter or summer—do you think this portrait was painted in?

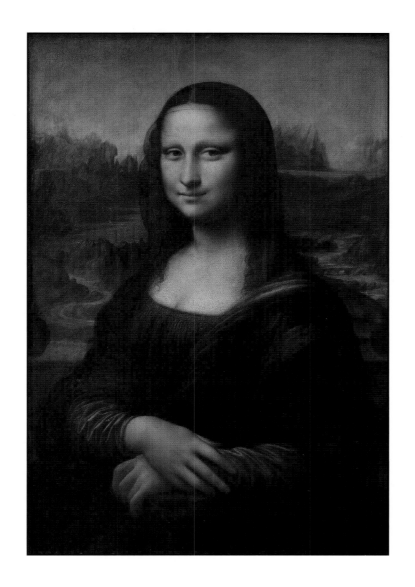

Portrait of Lisa Gherardini, Wife of Francesco del Giocondo (Mona Lisa)
c. 1504
Oil on panel
53 x 57 cm
Musée du Louvre, Paris, France

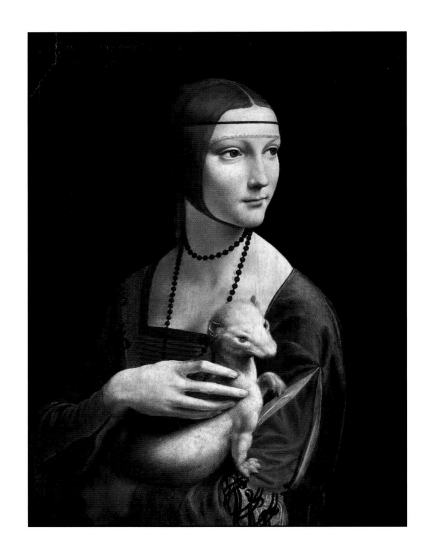

Lady with an Ermine
1496
Oil on panel
39.3 x 53.4 cm
The Princes Czartoryski
Museum,
Krakow, Poland

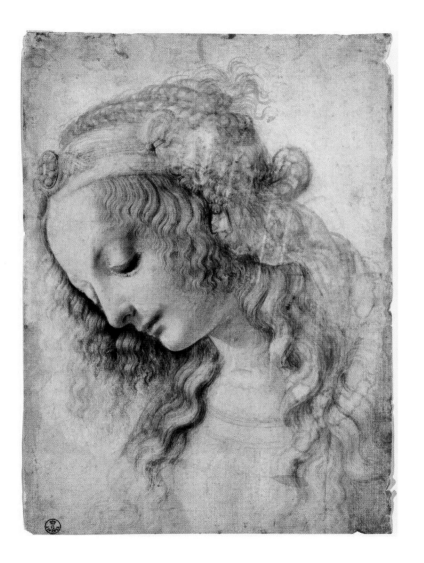

Study of a Woman
c. 1473
Ink on paper
28.2 x 19.9 cm
The Uffizi Gallery,
Florence, Italy

Titian

c. 1489 to 1576
Italian, lived in the Republic of Venice (Italy)

Interesting Fact: *Golden red hair is called titian colored after the bright auburn (another word for red) hair of many of the women in Titian's paintings.*

Titian's name was Tiziano Vecellio, which is a really hard name for people who do not speak Italian to pronounce! It's a good thing he has a nickname. (Hint: Search on the Internet to find how to pronounce names and words you do not know.) Nobody knows exactly when Titian was born, but when he was about 10 years old he moved with his brother to the city of Venice in northeast Italy. Venice is built on 118 small islands. Instead of roads, Venetians (people who live in Venice) travel by canals in gondolas (boats). Bridges connect the islands so people can walk from one island to another. When he was younger, Titian mainly made paintings for churches or paintings with a sacred (holy) theme in the Christian religion. On the facing page is *The Madonna of the Rabbit*. Mary, the mother of Jesus, is in the center of the picture reaching out to Jesus who is wrapped in a white cloth. Titian is also known for his portraits. You will see the portraits of Empress Isabel of Portugal and 2-year-old Clarissa Strozzi when you turn the page. Mythological stories about Greek and Roman gods and goddesses also interested Titian. He called his collection of mythological paintings "poesie," another word for poetry.

Self-portrait of the artist
around the age of 74

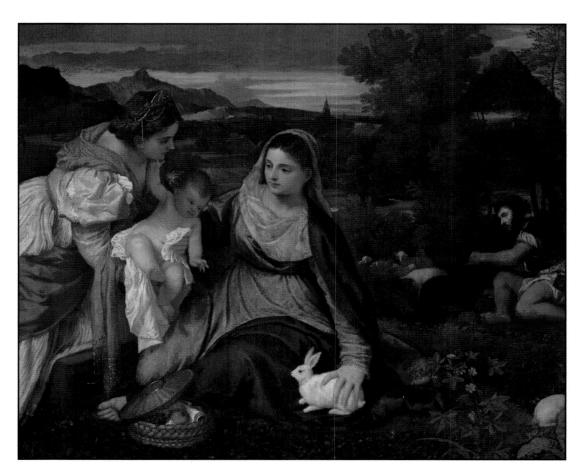

The Virgin and Child with Saint Catherine and a Shepherd (The Madonna of the Rabbit)
c. 1525–30
Oil on canvas
71 x 87 cm
Musée du Louvre,
Paris, France

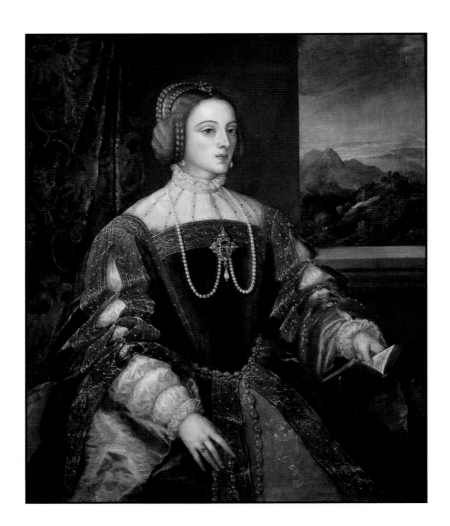

The Empress Isabel
of Portugal
1548
Oil on canvas
117 × 98 cm
Museo del Prado,
Madrid, Spain

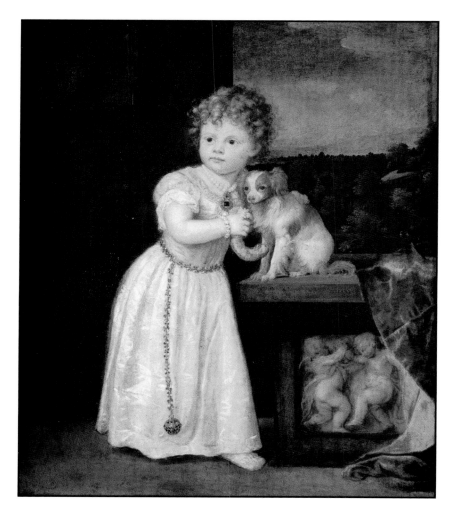

*Portrait of Clarissa Strozzi
at the Age of Two*
1542
Oil on canvas
115 x 98 cm
National Museums,
Berlin, Germany

Rembrandt

1606 to 1669
Dutch, lived in the Netherlands

Interesting Fact: *Historical portraits teach us a lot about the clothing styles of the women and men who lived a long time ago. The portrait of Agatha Bas on the next page shows her wearing a lace collar and cuffs and a pearl necklace. She is holding a golden fan.*

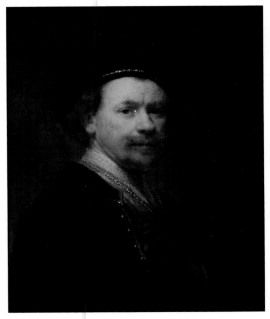

Self-portrait of the artist
around the age of 31

Rembrandt van Rijn was born in Holland, also called the Netherlands, a country known for windmills, tulips, wooden shoes, ice skaters on frozen canals, and earthen dams built to keep the ocean from flooding the low-lying countryside. Known only by his first name, Rembrandt lived and worked in Amsterdam, a city like Venice, Italy, that is built around canals. He is a famous portraitist and inspired other artists who painted in a realistic style. To create *A Girl at the Window*, Rembrandt applied his pigments with brushes, a palette knife, and even used his fingers. But as much as he liked to paint, Rembrandt liked to make etchings. To make an etching, Rembrandt covered a piece of metal in wax, then scratched off the wax with an etching needle to make a picture. When Rembrandt was pleased with his design, he dipped the metal plate in acid. The acid ate away the metal where the wax was scratched off. After the wax was cleaned off the metal plate, Rembrandt rolled ink over the design and pressed the plate onto a piece of paper. Voila! The etched drawing appeared!

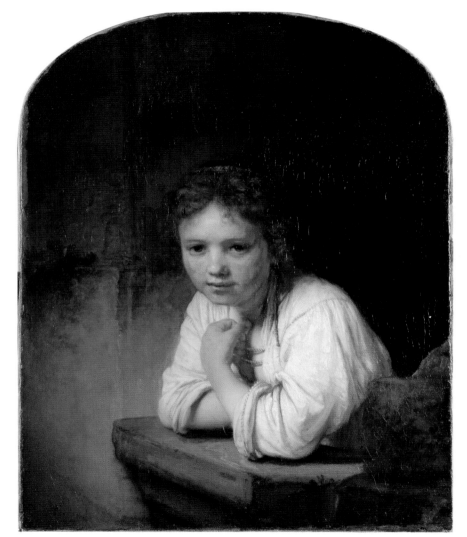

A Girl at a Window
1645
Oil on canvas
81.6 x 61 cm
Dulwich Picture Gallery,
London, England

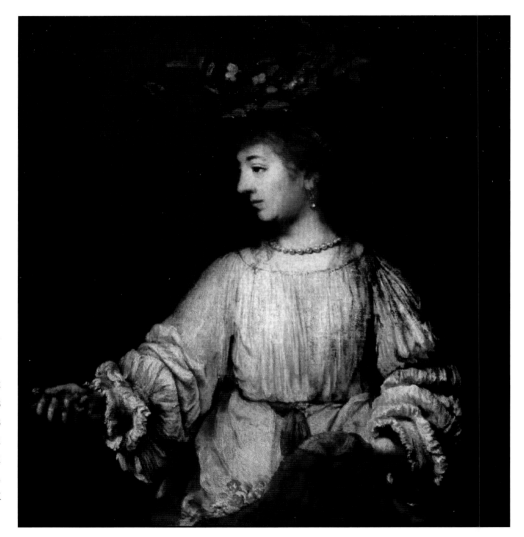

Flora
Early 1650s
Oil on canvas
100 x 91.8 cm
The Metropolitan
Museum of Art,
New York, New York

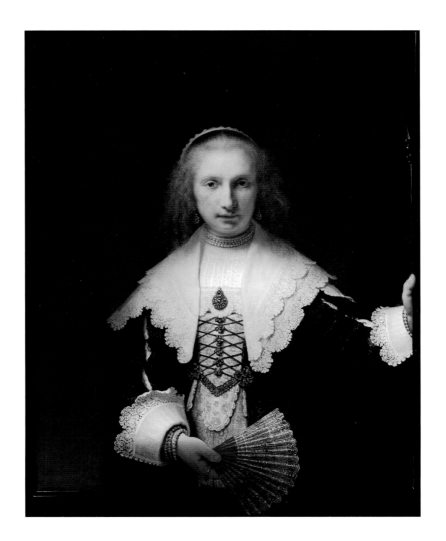

Agatha Bas
1641
Oil on canvas
105.5 x 83.9 cm
Royal Collection Trust,
United Kingdom

Johannes Vermeer

1632 to 1675
Dutch, lived in the Netherlands

Interesting Fact: *Johannes Vermeer was the father of 11 children and the creator of less than 50 paintings, a very small number compared to other painters. Only 36 paintings are known today.*

Johannes Vermeer is famous because his paintings look almost like photographs. The way he made his paintings look so real is a big mystery. Some people think he may have used a camera obscura—a very early kind of camera—to help him make the colors in his paintings so vivid and rich. His favorite subjects were women and girls going about their daily tasks, as you will see when you turn the page. But first, notice *The Girl with a Pearl Earring*. This type of painting is called a "tronie" (face) and is different from a portrait. A portrait is a painting of a specific person. A tronie tries to copy the expression on a model's face. What could the girl with the pearl earring be thinking about or looking at? There are so many possibilities! In *The Music Lesson*, on the next page, a girl is practicing the harpsichord while her teacher stands beside her. Do you see her reflection in the mirror on the wall? In *The Milkmaid* the maid is pouring milk from a pitcher into a bowl. What colors do you see in the paintings? Both paintings have windows that let the sunshine stream into the room. The sunlight makes the colors glow.

Believed self-portrait of the artist
at the age of 24

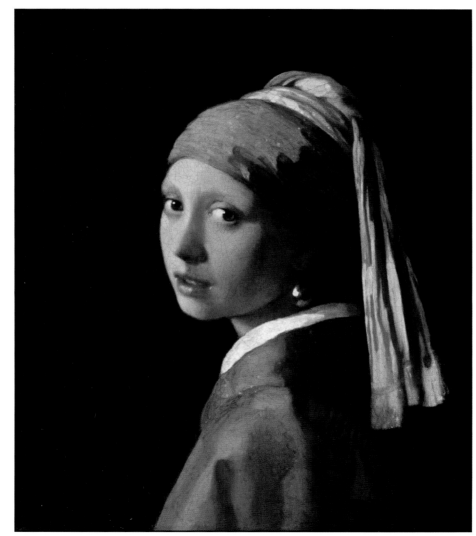

The Girl with the Pearl Earring
1665
Oil on canvas
46.5 x 40 cm
Royal Picture Gallery
Mauritshuis, The Hague,
The Netherlands

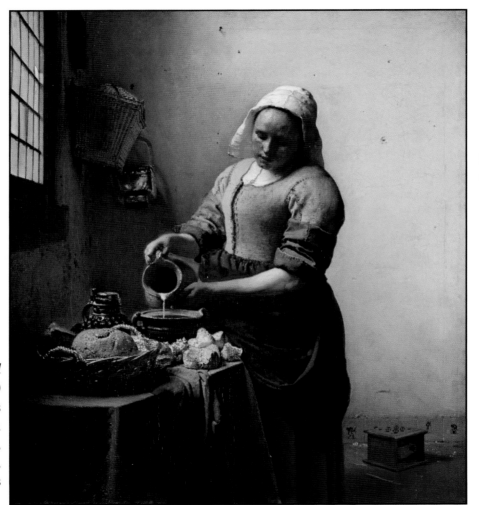

The Milkmaid
1660
Oil on canvas
45.5 x 41 cm
Rijksmuseum,
Amsterdam,
The Netherlands

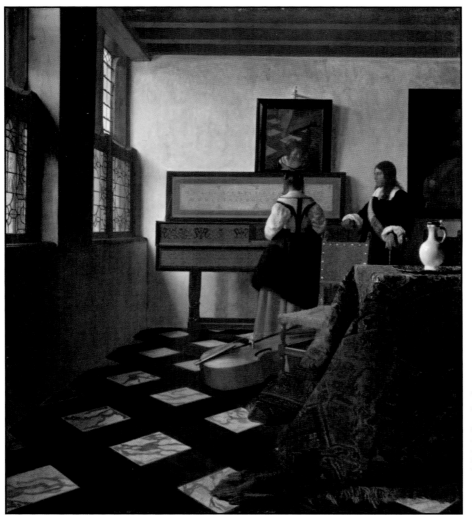

The Music Lesson
c. 1662–65
Oil on canvas
64.6 x 74 cm
Royal Collection Trust,
London, England

Thomas Gainsborough

1727 to 1788

English, lived in England

Interesting Fact: *At the age of 13, Gainsborough went to London, the capital city of England, to study painting and drawing. He was a child prodigy, someone who at a very young age is extremely good at a particular skill—in this case, art.*

Self-portrait of the artist around the age of 31

Thomas Gainsborough is another famous portrait painter, but his first love was painting landscapes and rustic (simple) scenes in the countryside of England where he lived. He was a practical man, however, and painted portraits to earn money. Often he would combine both types of painting as in *The Painter's Daughters Chasing a Butterfly*. In the background of the painting is a wood with trees and shrubbery, all parts of a landscape. In the foreground are the portraits of his daughters, Mary and Margaret. Later in his life, Gainsborough and has wife and daughters moved to a city in England called Bath—just like the word for your daily washing up! Bath is a city with hot water springs that bubble up from the ground and make pools for people to bathe in. A place like this is called a spa. When people visited the spas in Bath to relax, Gainsborough painted their portraits. In fact, Gainsborough was such an important artist that when King George III of England founded The Royal Academy of Arts in 1768, he asked him to be a founding member. The Royal Academy still exists today in London.

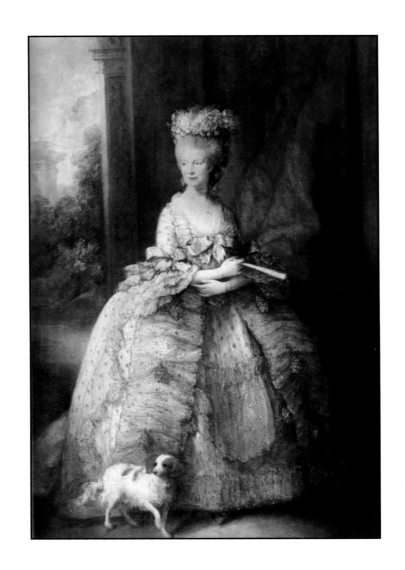

Queen Charlotte
1781
Oil on canvas
238.8 x 158.7 cm
Royal Collection Trust,
United Kingdom

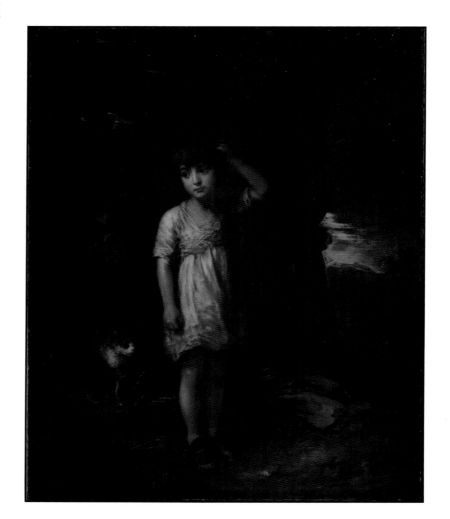

A Boy with a Cat—Morning
1787
Oil on canvas
150.5 x 120.7 cm
The Metropolitan
Museum of Art,
New York, New York

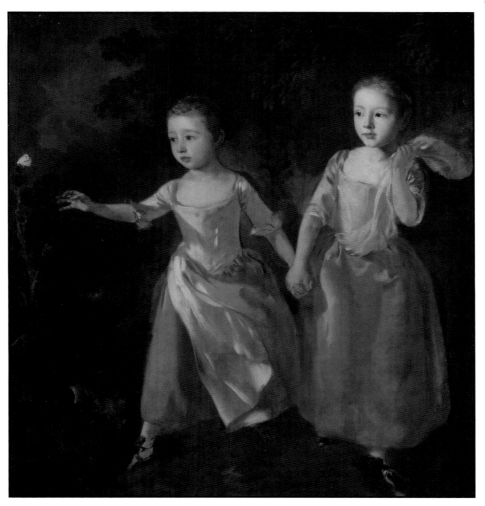

*The Painter's Daughters
Chasing a Butterfly*
1759
Oil on canvas
104 x 113.7 cm
The National Gallery,
London, England

Jean-Honoré Fragonard

1732 to 1806
French, lived in France

Interesting Fact: *Some of Jean-Honoré Fragonard's most famous paintings were created for a château (large country home) in France. After an argument with Madame du Barry, the owner of the château, the paintings were returned to him and never hung in the château, but you can see them in museums and books today.*

Self-portrait of the artist
around the age of 33

Jean-Honoré Fragonard studied in Paris, France, and in Rome, Italy. At the time he began to paint, artists followed a very traditional style. But Fragonard did not follow the crowd. Instead he followed one of his teachers, François Boucher, and adopted a new style called rococo. Isn't rococo a fun word to say? Rococo painters used delicate colors and curves to create playful, carefree outdoor scenes of love and romance. The unblended brushstrokes on Fragonard's paintings show that he worked very quickly. After Fragonard had a family, he began to paint pictures of families. One of these paintings is *The Visit to the Nursery*. Art experts believe that Fragonard may have been illustrating a fictional book (a made-up story) that was popular at the time. What story would you make up about the picture? A mystery surrounds the girls in the painting *The Two Sisters*. No one knows who they are. Another mystery is the "fantasy portrait" that lies underneath *Young Girl Reading*. Fragonard painted his fantasy portraits, mostly of girls sitting quietly, very quickly—in less than an hour. When he needed a new canvas, he just painted over them!

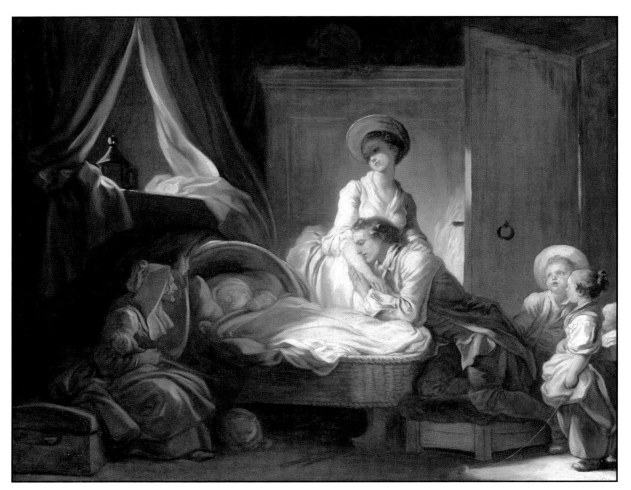

The Visit to the Nursery
1775
Oil on canvas
73 x 92.1 cm
National Gallery Art,
Washington, DC

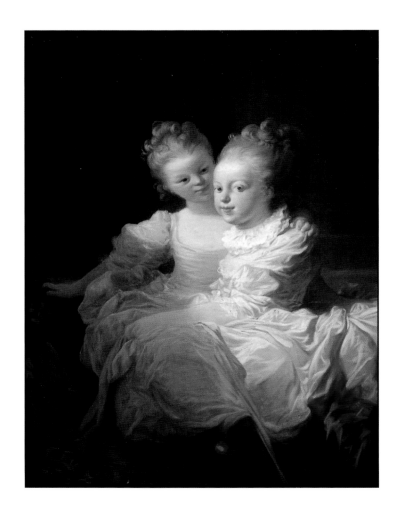

The Two Sisters
c. 1769–70
Oil on canvas
71.8 x 55.9 cm
The Metropolitan
Museum of Art,
New York, New York

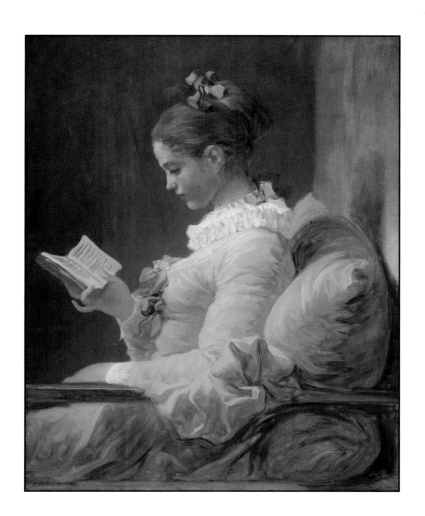

Young Girl Reading
c. 1770
Oil on canvas
81.1 x 64.8 cm
National Gallery of Art,
Washington, DC

Camille Corot

1796 to 1875
French, lived in France

Interesting Fact: *Camille Corot (pronounced without the "t"!) let his students copy his paintings in order to practice. Then he signed them as if he had painted them himself. That makes for a lot of confusion!*

Self-portrait of the artist
around the age of 39

Jean-Baptiste-Camille Corot was born in Paris, France. His father was a cloth merchant and his mother was a milliner, a hat maker. Landscapes were Corot's favorite subject. He made many trips to Italy and was at his happiest when he was painting the Italian landscape. He painted in the open air when the weather was warm and nice. He also made drawings in notebooks so that when the weather was cold and rainy he could paint indoors in his studio by looking at what he had drawn in his notebooks. *Souvenir of Mortefontaine* is one of Corot's landscapes. The title means a remembrance of Mortefontaine, which is a village near Paris that has a big park with many lakes. But Corot painted figures (people), too. Does the painting *The Letter* remind you of an artist you have read about already? Does the light shining on the girl look like the light shining on the girls in Vermeer's paintings? Maybe Corot saw Vermeer's paintings and tried to paint the way the light shines in his paintings, the same way that Vermeer did. Artists often learn and get ideas from other artists. When this happens we say one artist is inspired by another artist.

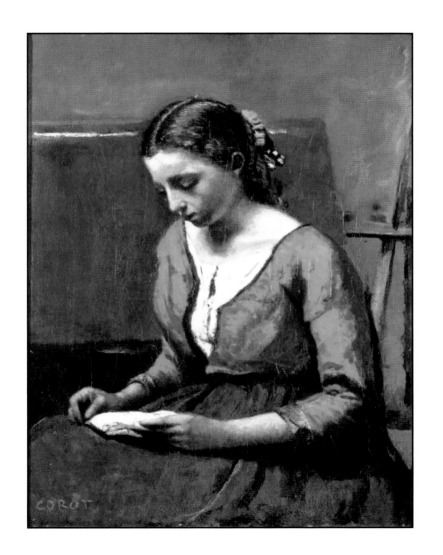

A Girl Reading
c. 1845–50
Oil on canvas
42.5 x 32.5 cm
Foundation E.G. Bührle
Collection,
Zurich, Switzerland

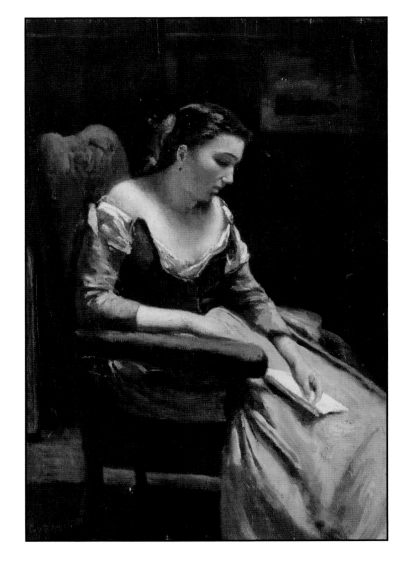

The Letter
c. 1865
Oil on wood
54.6 x 36.2 cm
The Metropolitan
Museum of Art,
New York, New York

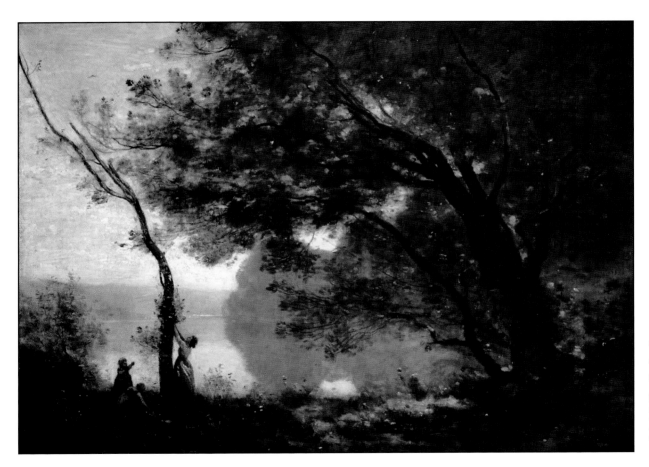

Souvenir of Mortefontaine
c. 1864
Oil on canvas
65 x 89 cm
Musée du Louvre,
Paris, France

Jean-François Millet

1814 to 1875
French, lived in France

Interesting Fact: *Jean-François Millet (pronounced "Mil-lay") was named after Saint Francis of Assisi, a Roman Catholic monk who lived in great poverty and taught the Christian value of charity, or helping people in need. Millet also lived as one among the poor and believed in sharing what little he had with his neighbors.*

Peasants, or poor farmers, were the subjects that Jean-François Millet painted the most. He was a peasant too. He lived in a town called Barbizon in a large forest near Paris, France. He painted his neighbors working in the fields, often harvesting grains, such as wheat and corn. Even though his neighbors were poor and did not have much money or live in big houses, Millet showed them as being proud and content living their lives. He gave them dignity. The painting *Charity* shows a little girl taking food to an old man who is hungry and waiting outside the door. Perhaps Millet was painting his own daughter (he had nine children) in this act of kindness. The mother, friend, or big sister in *The Knitting Lesson* is also showing kindness to the little girl who is learning how to knit. It can be hard to learn how to do something new. It is nice when someone helps you. Millet added spots of bright color to his paintings. What brightly colored objects can you find in these paintings by Millet?

Self-portrait of the artist
at the age of 27

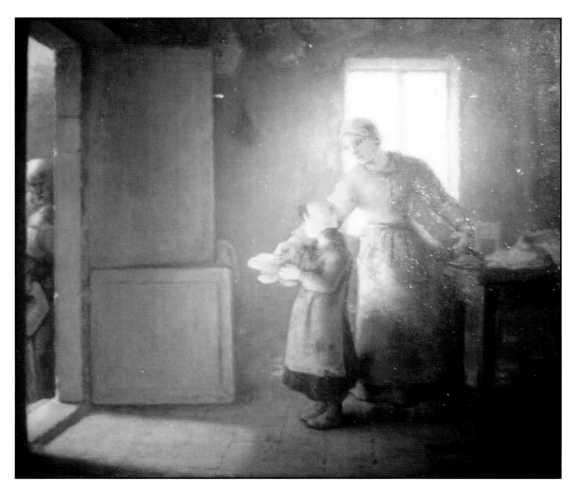

Charity
1859
Oil on panel
40 x 45 cm
Musée Thomas Henry,
Cherbourg, France

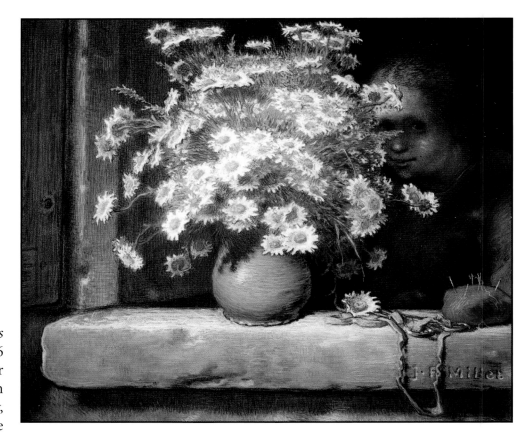

The Bouquet of Margueritas
1866
Pastel on paper
70.3 x 83 cm
Musée d'Orsay,
Paris, France

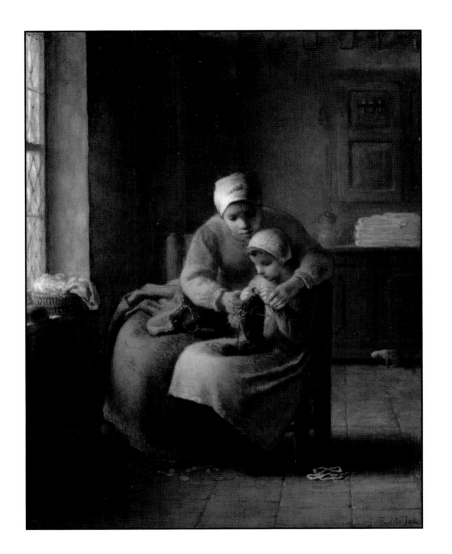

The Knitting Lesson
c. 1860
Oil on panel
41.5 × 31.9 cm
Sterling and Francine Clark
Art Institute,
Williamstown, Massachusetts

Gustave Courbet

1819 to 1877

French, lived in France and Switzerland

Interesting Fact: Gustave Courbet was a leader of the art style known as Realism. He believed that painters should only paint what they could see around them—real people, real houses, real animals, real flowers. Not every artist believes this. Some artists prefer a style called abstract art. Paul Klee, the last artist in this book, does. You will see!

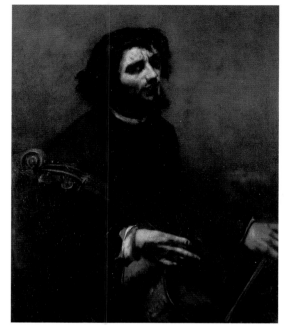

Self-portrait of the artist around the age of 28

Gustave Courbet went to Paris, France, when he was 20 years old to study law, but soon stopped his lessons so that he could paint. One way he learned to paint was to visit the Louvre Museum in Paris, one of the most famous museums in the world. Like many other artists, he copied the paintings of the Old Masters to practice his drawing and painting skills. The Old Masters were artists who lived many years earlier. Two Old Masters whose works Courbet copied and whom you have read about in this book are Rembrandt and Titian. Courbet's early subjects were the people who lived in his home village. He painted them doing normal things. Sometimes Courbet used a very big canvas. Until that time a very big canvas was used only for historical (an event that happened in the past) paintings. Many people did not like that Courbet broke this unwritten rule. He broke the rule because he believed that the lives of people who lived in his time were just as important as the lives of people who lived before him.

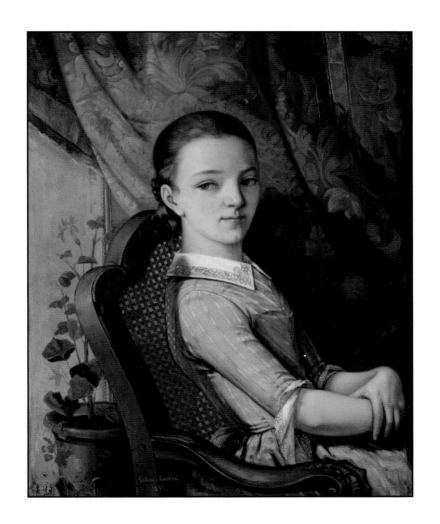

Portrait of Juliette Courbet
1844
Oil on canvas
77.5 x 62 cm
Petit Palais, City of Paris
Fine Art Museum,
Paris, France

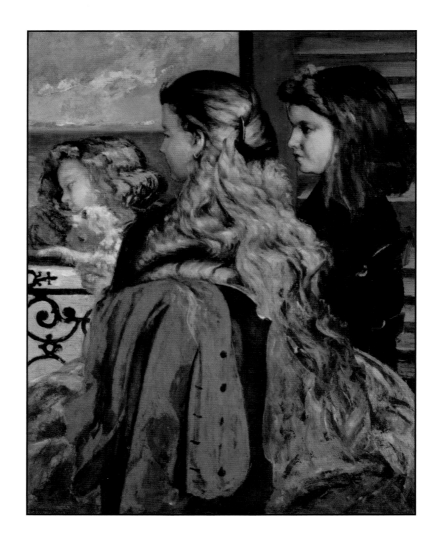

*Three English Girls
at a Window*
1865
Oil on canvas
93 x 73 cm
Ny Carlsberg Glyptotek,
Copenhagen, Denmark

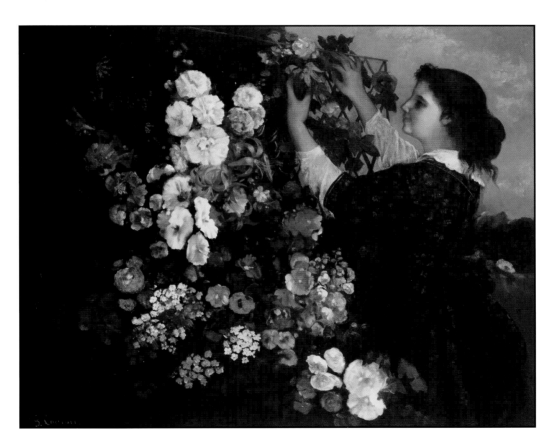

The Trellis
1862
Oil on canvas
109.8 x 135.2 cm
Toledo Museum of Art,
Toledo, Ohio

Alfred Stevens

1823 to 1906

Belgian, lived in Belgium and France

Interesting Fact: *In Paris, France, where Alfred Stevens lived most of his life, a street is named after him. It is called rue Alfred-Stevens! Rue is the French word for street.*

Alfred Stevens was born in Brussels, Belgium. (I bet you have eaten Brussels sprouts. They are named after this city because they were very popular there a long, long time ago.) Alfred Stevens came from a family that worked in the visual arts, that is, works of art in the form of a painting, photograph, or sculpture. Unlike many other artists, his father approved of his wanting to paint and helped him. Stevens is best known for painting young women in pretty dresses going about their daily lives. His paintings are almost like fashion magazines for the time he lived in. In *The Painter and His Model*, the man, who is the painter in the picture, could be Alfred Stevens. This means that he painted a self-portrait, a picture of himself. If you draw a picture of yourself, you have drawn a self-portrait, too. The model is looking over the painter's shoulder at his canvas. If you look really hard, you can see a girl on the canvas in a yellow dress, just like the one the model is wearing. The painting *Departing for the Promenade* is also called *Will You Go Out with Me, Fido?* Can you make up a story about the lady in the painting and Fido? Do you think it is her dog?

Photograph of the artist
at the age of 42

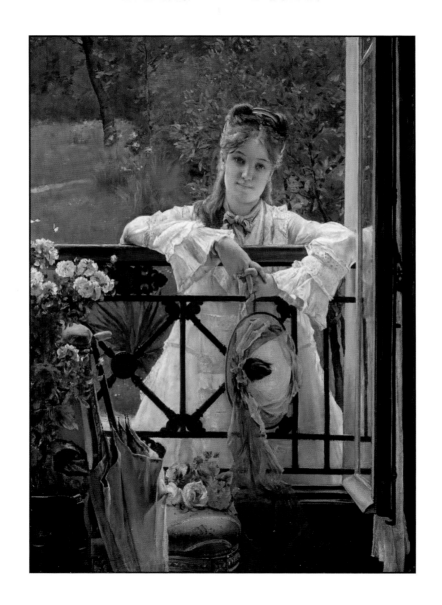

The Blue Ribbon
1862–64
Oil on panel
77 x 55 cm
Private Collection

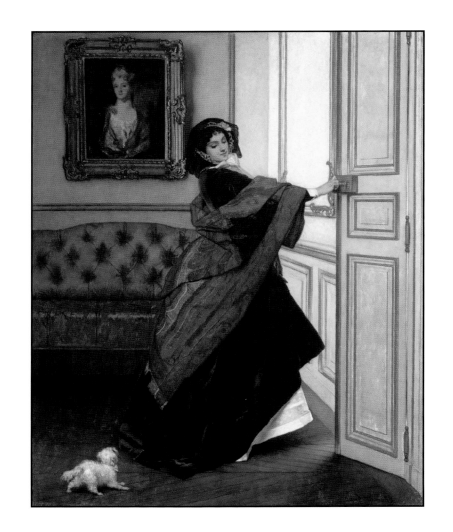

Departing for the Promenade (Will You Go Out with Me, Fido?)
1859
Oil on panel
61.6 x 48.9 cm
Philadelphia Museum of Art, Philadelphia, Pennsylvania

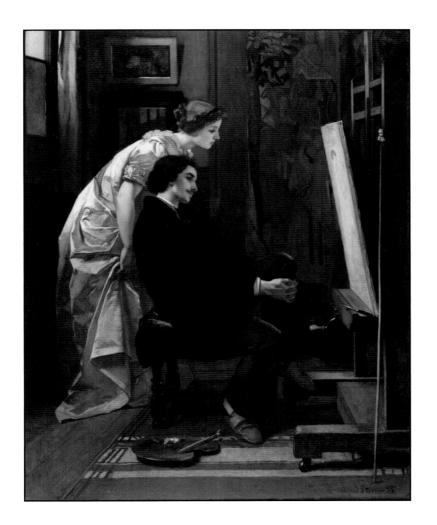

The Painter and His Model
1855
Oil on fabric
92.4 x 77.3 cm
The Walters Art Museum,
Baltimore, Maryland

Edouard Manet

1832 to 1883
French, lived in France

Interesting Fact: *Edouard Manet wanted to be a naval officer, but he did not pass the entrance exam. Twice. So, he set his sights on becoming an artist instead. And in art he was quite successful! Many art experts call him the "father of modernism."*

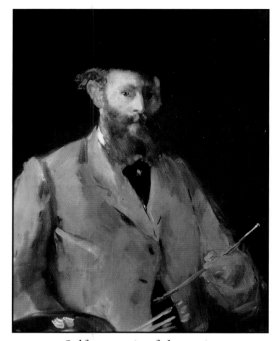

Self-portrait of the artist
at the age of 47

Edouard Manet began studying art by copying the Old Masters at the Louvre Museum in Paris, France. He became close friends with other artists working in Paris at the time. (You will read about them later in this book.) He met one of them, Edgar Degas, when they were both copying paintings in the Louvre. Berthe Morisot is another. She married his brother. A third is Claude Monet. At first, Manet was upset because he thought Monet was copying his style. To make matters worse, Manet's name looks a lot like Monet's name, so that Manet's signature on his paintings looked much like Monet's signature. Soon all was forgotten and the two men became very good friends. Manet also painted with Auguste Renoir. These friends of Manet belonged to a group of artists who were called the Impressionists, but Manet did not belong. The paintings on the next pages include two of his artist friends. *The Monet Family in Their Garden in Argenteuil* is the family of Claude Monet. Argenteuil is a town near Paris where Manet and his artist friends lived and painted. Berthe Morisot is the lady sitting in the chair in *The Balcony*.

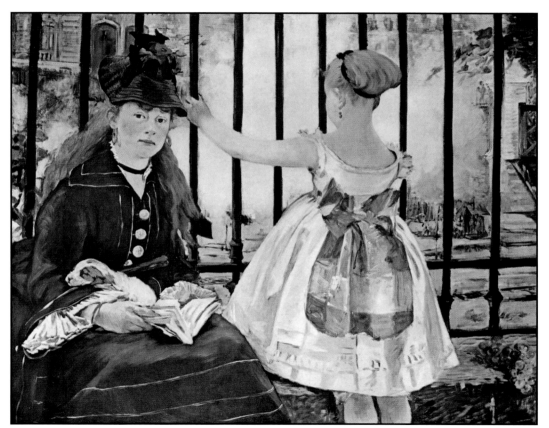

The Railway
1873
Oil on canvas
93.3 x 111.5 cm
National Gallery of Art,
Washington, DC

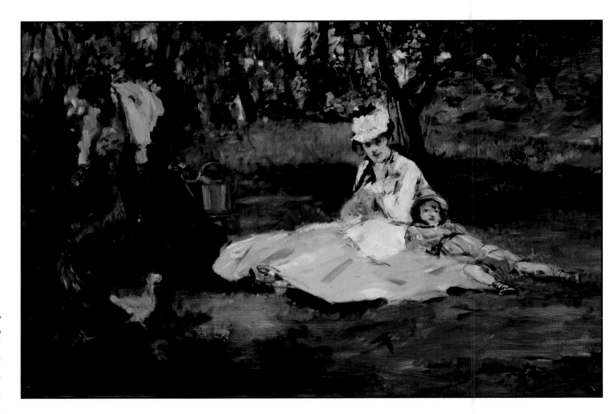

*The Monet Family in Their
Garden at Argenteuil*
1874
Oil on canvas
61 x 99.7 cm
The Metropolitan
Museum of Art,
New York, New York

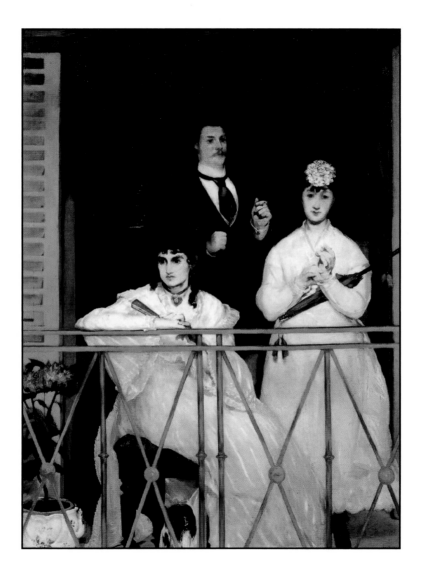

The Balcony
1868–1869
Oil on canvas
170 x 125 cm
Musée d'Orsay,
Paris, France

James Abbott McNeill Whistler

1834 to 1903

American, lived in France and England

Interesting Fact: *Whistler named his artworks using the language of music. He called them symphonies, compositions, harmonies, nocturnes, and arrangements.*

James Abbot McNeill Whistler was born in the United States, but his family soon moved to St. Petersburg, Russia. His father was helping to build a railroad there. When he grew up, Whistler, like Edouard Manet, wanted to be in the military but failed. Instead, like Manet, he became an artist and it was a very good idea! Often what looks like a roadblock is just a detour to the place you are really meant to go. At first Whistler studied in Paris, then moved to London, England, where he lived for the rest of his life. Whistler used the first letter in each of his names to create a butterfly design that he put in his paintings as a way of signing his name. He must have liked butterflies a lot. Do you see the butterflies in the painting on the opposite page? Miss Cicely Alexander was 8 years old when he painted her portrait. Whistler wanted the picture to be perfect, so perfect in fact that he designed the dress of Indian muslin that she wore. On the next page, the painting *The White Symphony: Three Girls* is about beauty. And can you believe that the painting *The Symphony in White, No. 1: The White Girl* caused a furor (big upset) when it was shown to the public? It seems the lady was wearing her nightgown.

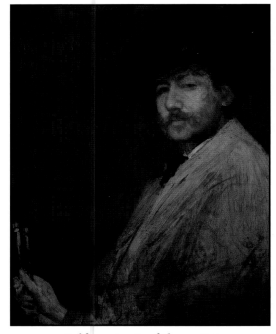

Self-portrait of the artist around the age of 41

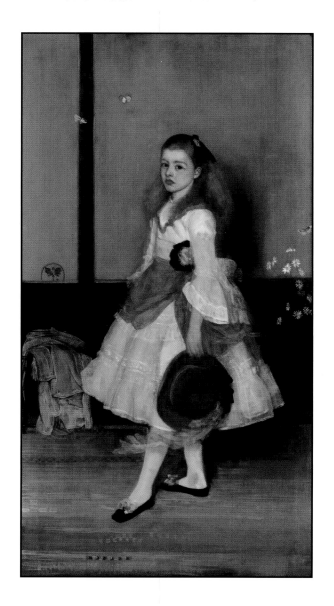

Harmony in Grey and Green: Miss Cicely Alexander
1872–74
Oil on canvas
90.2 x 97.8 cm
Tate Britain,
London, England

The White Symphony:
Three Girls
c. 1868
Oil on millboard
mounted on wood panel
46.4 x 61.6 cm
Freer Gallery of Art,
Washington, DC

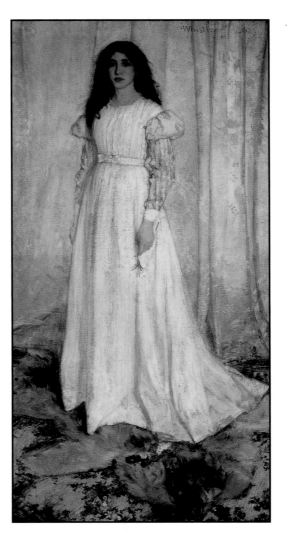

Symphony in White, No. 1:
The White Girl
1862
Oil on canvas
213 x 107.9 cm
National Gallery of Art,
Washington, DC

Edgar Degas

1834 to 1917

French, lived in France

Interesting Fact: *Edgar Degas is best known for painting ballet dancers and for a bronze sculpture of* The Little Fourteen–Year–Old Dancer. *She has a cotton tutu (ballet skirt) and a satin hair ribbon tied around a horsehair wig! But he loved to paint and sculpt horses and jockeys (the men who ride racehorses) just as much as he did dancers. Both dancers and horses are beautiful in motion.*

Edgar Degas was an Impressionist. At the time the Impressionists lived, their style of painting was considered quite modern. The works they created were like a sketch, a quickly drawn picture, which gave an impression (idea) of the figures and scenery in the painting. In contrast, Realist painters, such as Gustave Courbet, made their subjects look as real and detailed as possible. Degas grew up in Paris and copied many, many paintings at the Louvre Museum very, very carefully. He was a perfectionist. Degas did paint landscapes and he did paint out of doors, but these were not his favorite things. His true joy was to paint women, mostly dancers, but laundresses (ladies who wash clothes to make a living) and milliners (ladies who make hats) also were in his paintings. The painting on the opposite page called *The Millinery Shop* shows a milliner holding a hat that she is making. Next to her are finished hats with bows and flowers. On the next page are two paintings of ballet dancers. The dancers in pink are performing and the dancers in white are practicing (rehearsing).

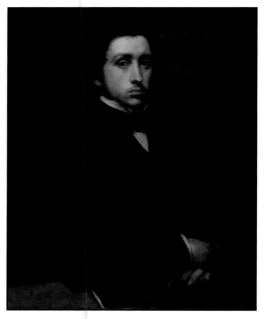

Self-portrait of the artist
at the age of 21

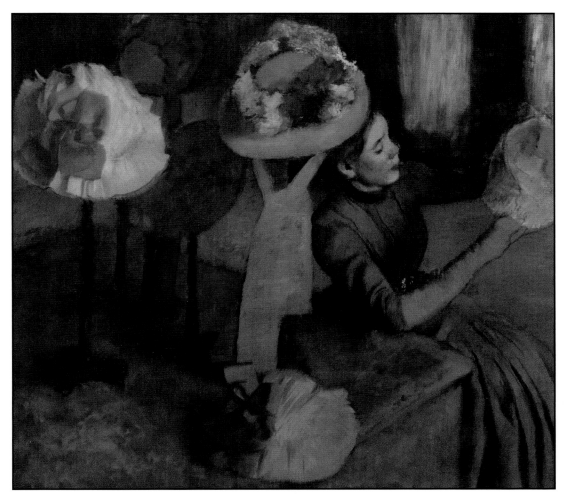

The Millinery Shop
1884
Oil on canvas
99.4 x 110.2 cm
The Art Institute
of Chicago,
Chicago, Illinois

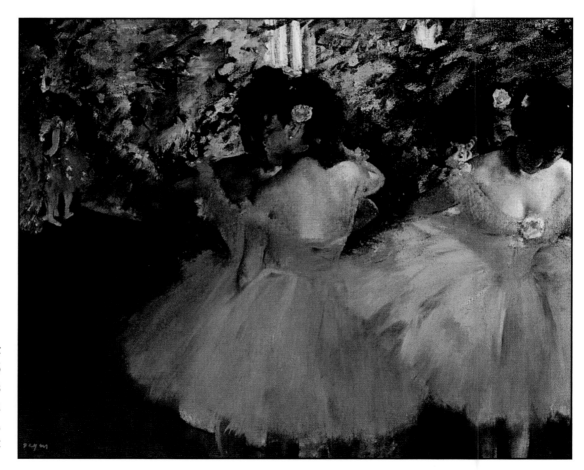

Dancers in Pink
c. 1876
Oil on canvas
59 x 74 cm
Hill-Stead Museum,
Farmington, Connecticut

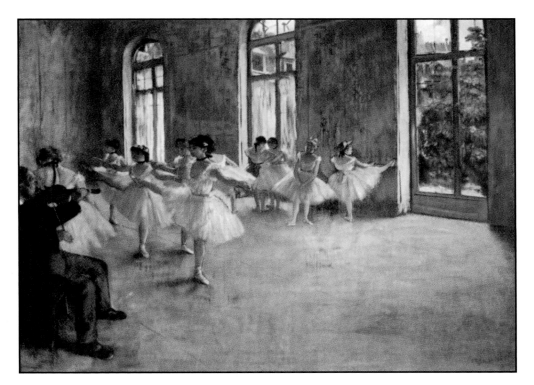

The Rehearsal
1873–78
Oil on canvas
45.7 x 60 cm
Fogg Museum,
Harvard Art Museums,
Cambridge, Massachusetts

Sir Lawrence Alma-Tadema

1836 to 1912

Dutch, lived in Belgium and England

Interesting Fact: *A British magazine called* Punch *said that Sir Alma-Tadema was a "marbellous" painter because when he painted marble it really looked like marble. "Marbellous" is what we call a play on the word "marvelous."*

Self-portrait of the artist
at the age of 60

Sir Lawrence Alma-Tadema was born in Holland and was originally named Laurens Alma Tadema. He is called "Sir" because the queen of England made him a knight, just like the knights who lived in castles many years ago. Alma-Tadema earned this high honor because of the excellence of his artwork. He also changed the spelling of his name to Lawrence to be more English. When he was learning to paint, his teacher taught him to make historical, classical paintings as true to the past as possible. He especially loved ancient Rome. Once, he visited the ruins of the city of Pompeii on the coast of Italy. The city was destroyed when the volcano Vesuvius erupted a very long time ago. Afterward, Pompeii was one of his favorite subjects. The house he lived in even looked like a villa from Pompeii. In the picture on the opposite page can you see the baby Moses held high in the basket? Do you know the Bible story of the baby Moses who was found in the Nile River by the pharoah's (Egyptian king's) daughter? On the next page, the painting *Our Corner* is of Sir Alma-Tadema's daughters, Anna and Laurense. Do you have a cozy corner where you can read and daydream like they did?

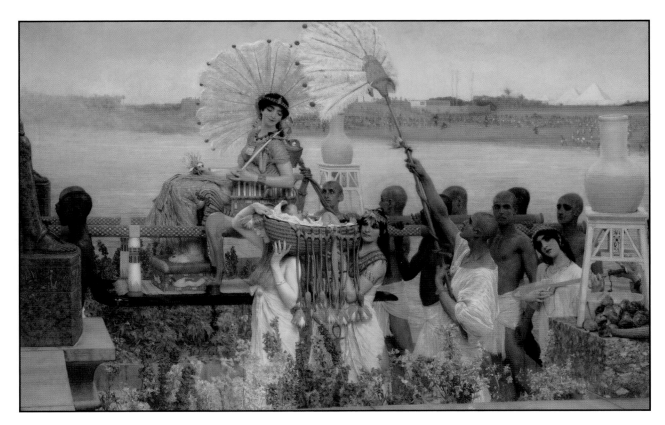

The Finding of Moses
1904
Oil on canvas
137.5 x 213.4 cm
Private Collection

Sir Lawrence Alma-Tadema

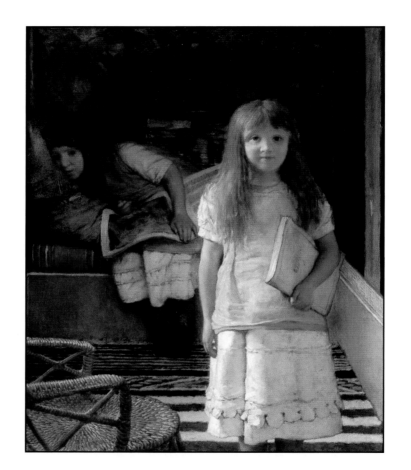

*Our Corner: Portrait of
Anna and Laurense
Alma-Tadema*
1873
Oil on canvas
56.4 × 47.8 cm
Van Gogh Museum,
Amsterdam,
The Netherlands

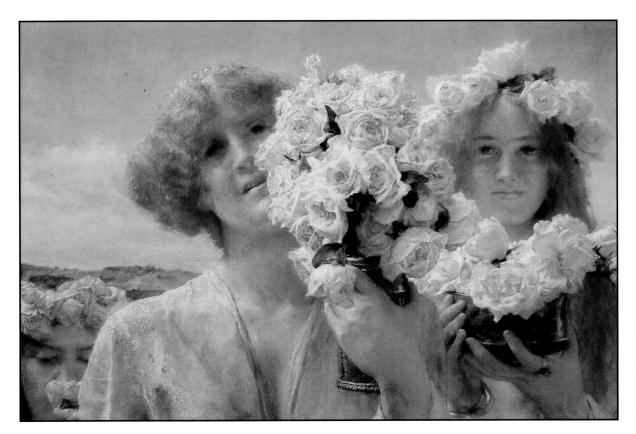

Summer Offering
1911
Oil on panel
36.2 x 52.7 cm
Brigham Young University
Museum of Art,
Provo, Utah

Paul Cézanne

1839 to 1906

French, lived in France

Interesting Fact: *Paul Cézanne's earliest works were painted with dark colors—browns, grays, and blacks. This is called his Dark Period. Then he met Camille Pissarro, often called the "father" of Impressionism, who taught Cézanne about the Impressionists' ideas. Suddenly, Cézanne began to use brighter, happier colors.*

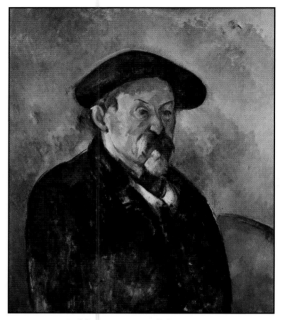

Self-portrait of the artist
around the age of 50

Paul Cézanne was born in southern France. He is a Post-Impressionist painter, which means his artistic style developed after Impressionism. He is said to be the "father" of more modern painters, such as Paul Klee (the last artist in this book), Henri Matisse, and Pablo Picasso, who lived and worked after Cézanne. Cézanne tried to paint the forms he saw in nature as simply as possible. For example, he would paint an orange or an apple as a sphere (like a ball). He also painted his family and friends in costumes. He painted his uncle three times. One time he was dressed as a lawyer, once as an artist, and once as a monk. The picture on the opposite page is a man in a colorful harlequin (clown) costume. Turn the page to see a painting of Cézanne's mother sitting on the sofa and his sister playing the piano. *The Basket of Apples* is a type of painting called a still life. A still life is exactly what it sounds like. Everything in the painting is still, not moving. What things compose (make up) this still life? Apples, a bottle, a basket, and a cloth or napkin. What could be on the plate at the back of the table?

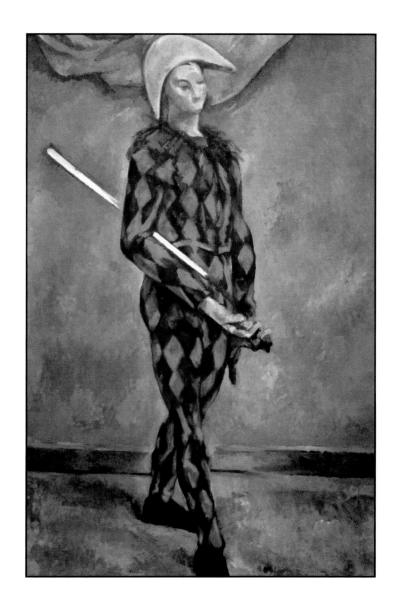

Harlequin
1888–90
Oil on canvas
101 x 65 cm
National Gallery of Art,
Washington, DC

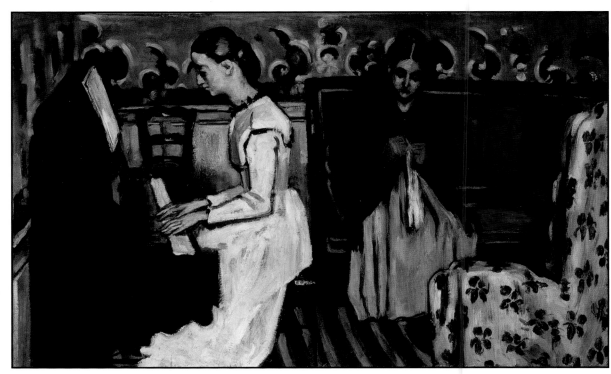

Girl at the Piano (The Overture to Tannhauser)
c. 1868
Oil on canvas
57.8 x 92.5 cm
The State Hermitage Museum,
St. Petersburg, Russia

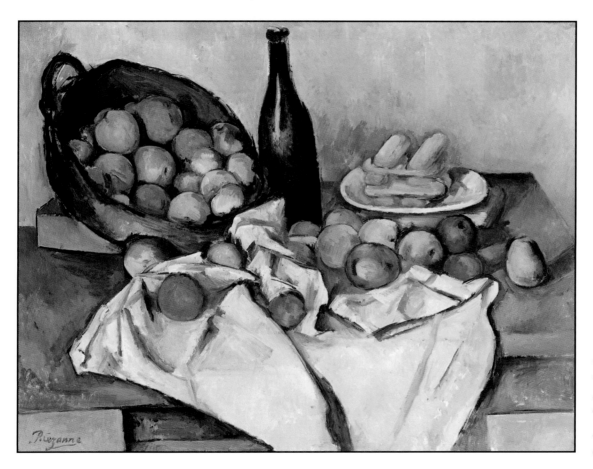

The Basket of Apples
c. 1893
Oil on canvas
65 x 80 cm
The Art Institute
of Chicago,
Chicago, Illinois

Claude Monet

1840 to 1926
French, lived in France

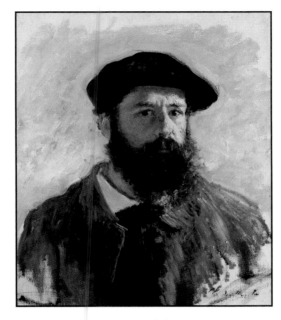

Self-portrait of the artist
at the age of 46

Interesting Fact: *Claude Monet was excited by nature. He was a gardener and tended his flowers on a large estate in Giverny, France. On his estate was a pond filled with water lilies. A Japanese footbridge arched over the pond. He painted the bridge over the water-lily pond many times. His garden is still in Giverny and you can visit it. It looks just like it did when he lived there.*

Claude Monet was fascinated by how changes in sunlight throughout the day and moonlight at night, as well as fog, rain, and snow, made colors change. To study these changes, Monet would paint a bridge, building, or even haystacks over and over again at different times of day and in different types of weather to see how the colors changed. A group of paintings on the same subject—haystacks, for example—is called a series. The boy in the painting on the opposite page is Claude Monet's elder son, Jean. Monet kept this painting with him always. He never exhibited it or sold it. He must have loved his son very much. On the next two pages are paintings of Monet's first wife, Camille, at their home in a village called Argenteuil. In the first painting, Camille is sewing in the garden while a little girl plays at her feet. In the second painting, Camille is standing in the door, watching Jean play hoop-and-stick. Jean had to keep the hoop rolling by pushing it with a stick. Have you ever played a game like this?

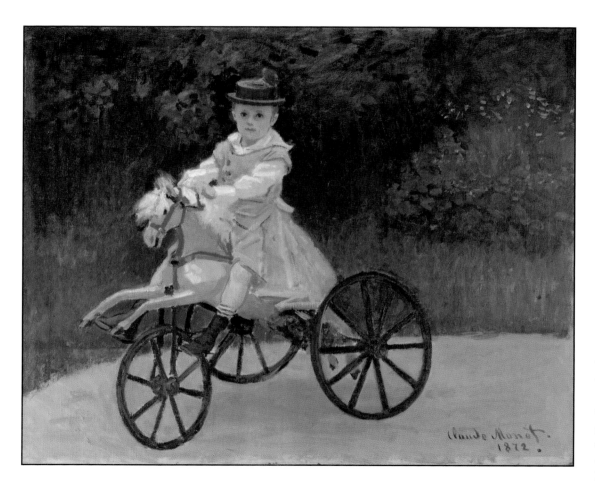

Jean Monet on His
Hobby Horse
1872
Oil on canvas
60.6 x 74.3 cm
The Metropolitan
Museum of Art,
New York, New York

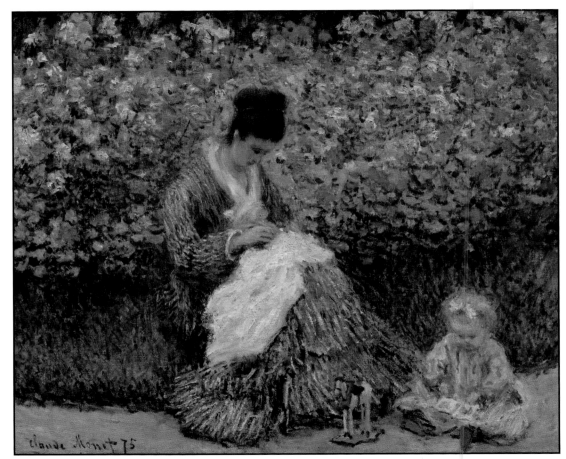

*Camille Monet and a Child
in the Artist's Garden
in Argenteuil*
1875
Oil on canvas
55.2 x 64.8 cm
Museum of Fine
Arts Boston,
Boston, Massachusetts

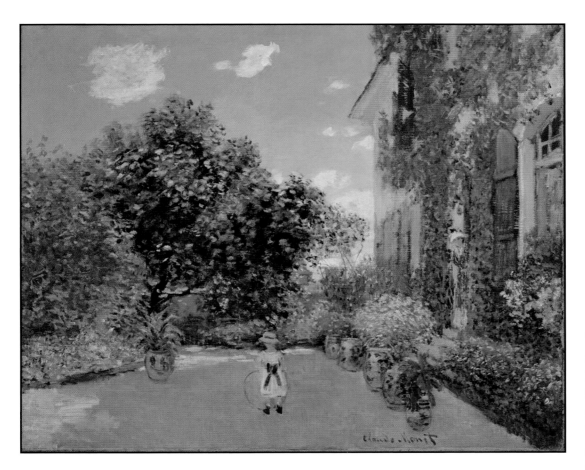

*The Artist's House
at Argenteuil*
1873
Oil on canvas
60.2 x 73.3 cm
The Art Institute
of Chicago,
Chicago, Illinois

Pierre-Auguste Renoir

1841 to 1919
French, lived in France

Interesting Fact: *In his old age, Pierre-Auguste Renoir suffered badly from arthritis, a disease of the joints. His fingers were paralyzed, which means he couldn't move them. So that he could paint, a paintbrush was tied onto his hand.*

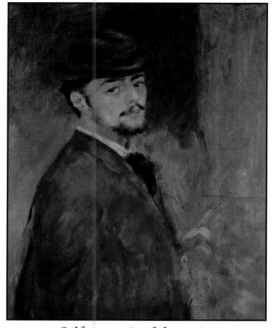

Self-portrait of the artist
at the age of 35

Pierre-Auguste Renoir painted in the Impressionist style. His paintings are brightly colored with brushstrokes that are easy to see. They show happy occasions. People in his paintings are boating and dancing or are at the theater, the seashore, a restaurant or a café. Renoir also painted portraits. The painting on the opposite page is of a mother and her two children. The child sitting next to the mother on the settee is 3-year-old Paul. His sister Georgette is sitting on their big, patient, black-and-white dog. The style of that time was for a young boy to wear a dress (in this case, just like his sister's blue, lacy dress) and to keep his ringlets uncut. They almost look like twins, don't they? The girls in the painting *Pink and Blue* on the next page are sisters named Alice and Elisabeth. Renoir also painted their older sister, Irene. And guess what? The girls in the painting *Two Sisters (On the Terrace)* are not sisters at all! The older girl is wearing a blue dress that ladies often wore at that time to go boating on the river. Can you see the river through the trees and the boats on the river?

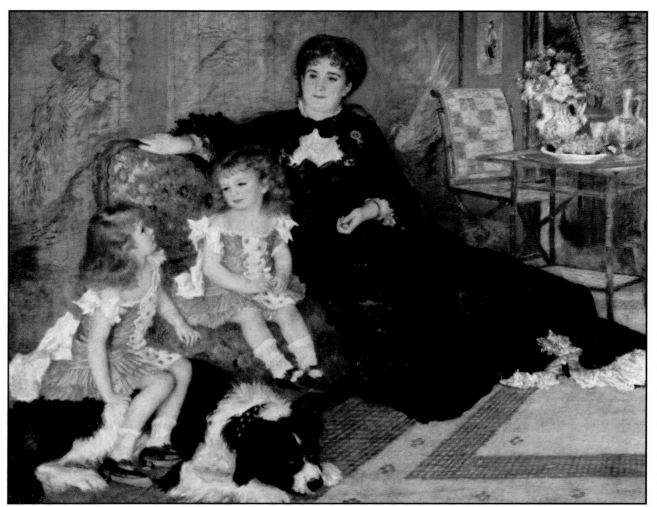

Madame Georges Charpentier and Her Children, Georgette–Berthe and Paul–Émile–Charles
1878
Oil on canvas
153.7 x 190.2 cm
The Metropolitan Museum of Art,
New York, New York

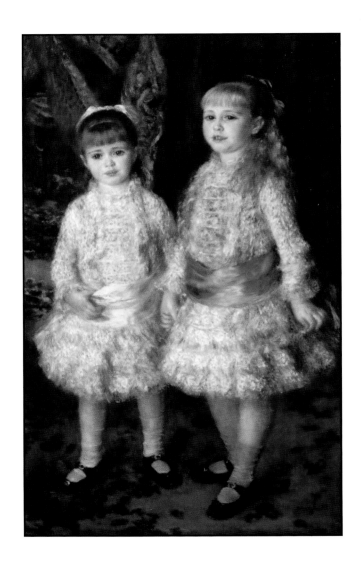

Pink and Blue
1881
Oil on canvas
119 x 74 cm
São Paulo Museum of Art,
São Paulo, Brazil

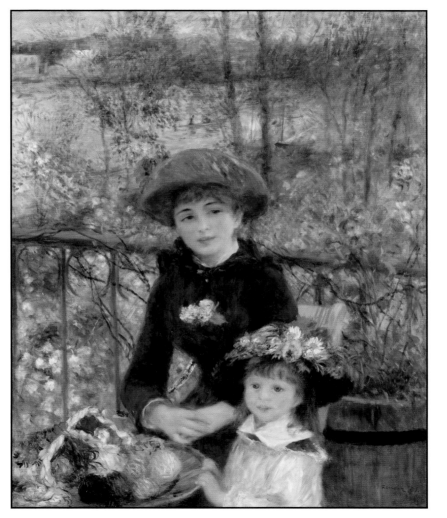

Two Sisters (On the Terrace)
1881
Oil on canvas
100.4 x 80.9 cm
The Art Institute
of Chicago,
Chicago, Illinois

Berthe Morisot

1841 to 1895
French, lived in France

Interesting Fact: *Berthe Morisot, along with the painter Mary Cassatt (you will read about her later in this book), were the only two women who officially belonged to the group of artists called the Impressionists.*

Berthe Morisot was encouraged by her mother to study art. She began by copying the Old Masters' paintings at the Louvre Museum in Paris, France, just like so many other artists. She was also taught to paint by Camille Corot, whom you already may have read about in this book. She was also a great friend of Edouard Manet. They probably met while they were copying paintings at the Louvre! She married his brother Eugène. Morisot's favorite subject was femininity, that is, ladies being ladies and girls being girls. *Woman at Her Toilette* shows a lady sitting at her dressing table. Toilette is an old-fashioned word for getting dressed. Surrounding the woman in soft shades of lavender, pink, blue, white, and gray are powder puffs, satin ribbons, and flower petals. When you turn the page you will see *The Cradle*, Morisot's most famous painting. Her sister Edma is looking at her daughter Blanche while she is sleeping in the cradle. Morisot's friend, Edouard Manet, came for a visit while she was working on *The Mother and Sister of the Artist*. Without her agreement he picked up her paintbrush and added a few brushstrokes!

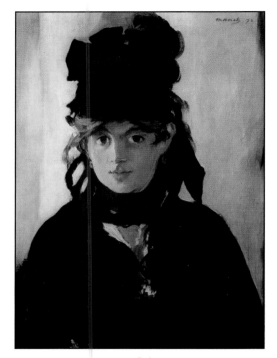

Portrait of the artist
at the age of 31
painted by Edward Manet

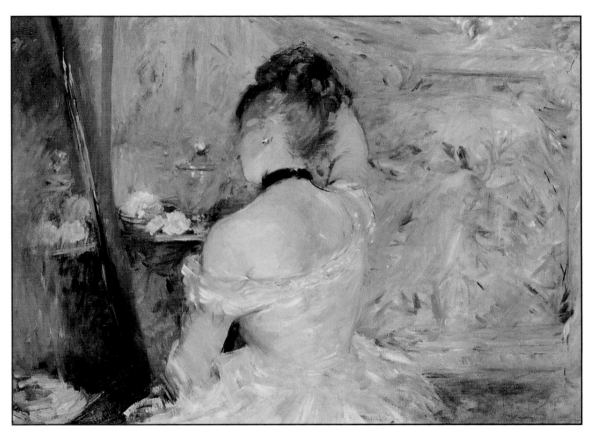

Woman at Her Toilette
1875–80
Oil on canvas
60.3 x 80.4 cm
The Art Institute
of Chicago,
Chicago, Illinois

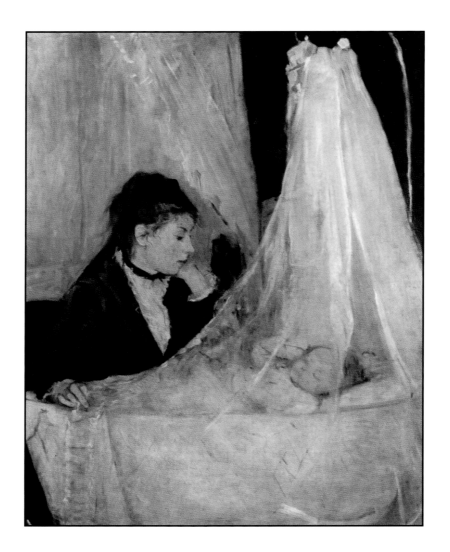

The Cradle
1872
Oil on canvas
46 x 56 cm
Musée d'Orsay,
Paris, France

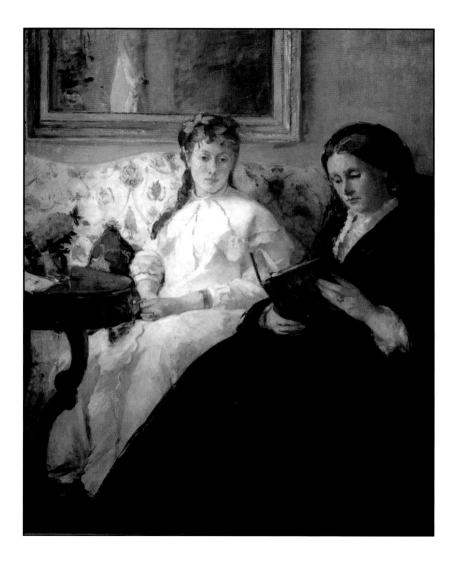

*The Mother and Sister
of the Artist*
1869–70
Oil on canvas
81.8 x 101 cm
National Gallery of Art,
Washington, DC

Giovanni Boldini

1842 to 1931
Italian, lived in France and England

Interesting Fact: Time *magazine called Giovanni Boldini the "Master of Swish" because of his sweeping brushstrokes on the canvas. A swish is a soft, broad movement. It can also be a soft sound. The fancy dresses of the ladies in his paintings look like they make a "swishing" noise when the ladies walk.*

Self-portrait of the artist
at the age of 50

Giovanni Boldini was born in Ferrara, Italy. His father was a painter, too. Boldini moved first to Florence, Italy, the home of many great art museums today, and later to Paris, France, where he became friends with Edgar Degas and Edouard Manet. Like the Impressionists, he painted outdoor scenes, but he is best known for his high society portraits. Boldini was also a friend of John Singer Sargent (his story and paintings are in this book, too). When Sargent moved to London, he let Boldini use his art studio. Sargent invited Boldini to visit him in London where Boldini painted portraits of British lords and ladies. Giovinetta Errazuriz was 10 years old when she "sat" (modeled) for Boldini. It looks like she was lucky to sit on a very comfortable sofa cushion! *The Hammock*, on the next page, shows very well the swish in Boldini's brushstrokes. Do you see the swish? *The Lascaraky Sisters* is in a museum just for Boldini's works. The other two Boldini paintings in this book are in private collections. They are in someone's home or office and are not on public display (that means you and I can't see them except in a book or on the Internet).

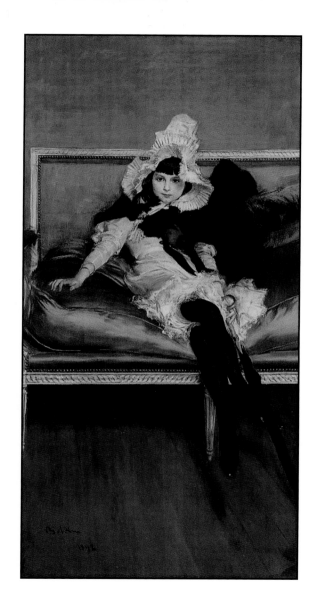

Giovinetta Errazuriz
1892
Oil on canvas
201 x 101 cm
Private Collection

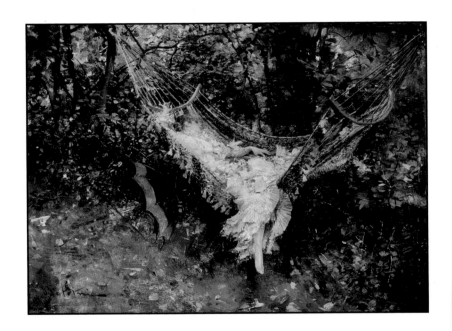

The Hammock
c. 1872–74
Oil on panel
18.4 × 14 cm
Private Collection

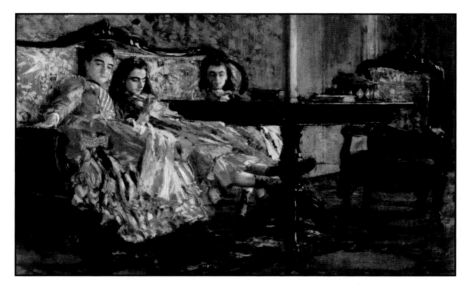

The Lascaraky Sisters
1869
Oil on canvas
14 x 22.5 cm
Museo Boldini,
Ferrara, Italy

Mary Cassatt

1844 to 1926

American, lived in France

Interesting Fact: *The Impressionist artist Edgar Degas invited Mary Cassatt to join the Impressionists in their exhibitions. She is the only official American Impressionist.*

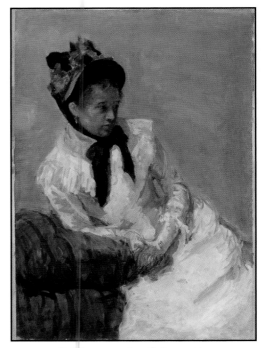

Self-portrait of the artist
at the age of 34

Mary Cassatt was born in Pennsylvania. Her father did not want her to be an artist, but she was allowed to study at the Pennsylvania Academy of the Fine Arts when she was 16 years old. Finally, her father agreed that she could move to Paris, France, to study. Like many artists, she was a copyist at the Louvre Museum. But she wanted to copy works of artists that hung in other museums, so she traveled to Spain, Belgium, and Holland. Her favorite subjects were figures rather than landscapes or still lifes. She is best known for her paintings of mothers and children, and she played a very important role in bringing Impressionist art to America. She collected (bought) it herself and asked her friends to add it to their collections. Many works from these collections are in America's museums today so that you can see them. Mary Cassatt did not have children, but she had a lot of nieces and nephews. She was around them so much that she painted them doing things children like to do—playing on the beach and sitting in their mother's lap. The little girl who posed for *Child in a Straw Hat* doesn't look very happy, does she? Why do you think that might be?

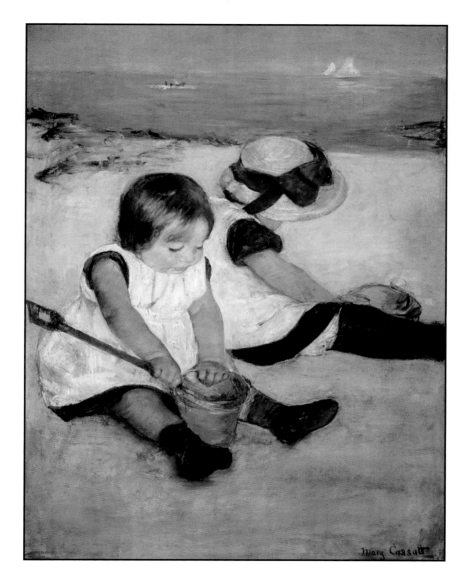

*Children Playing
on the Beach*
1884
Oil on canvas
97.4 x 74.2 cm
National Gallery of Art,
Washington, DC

Mary Cassatt

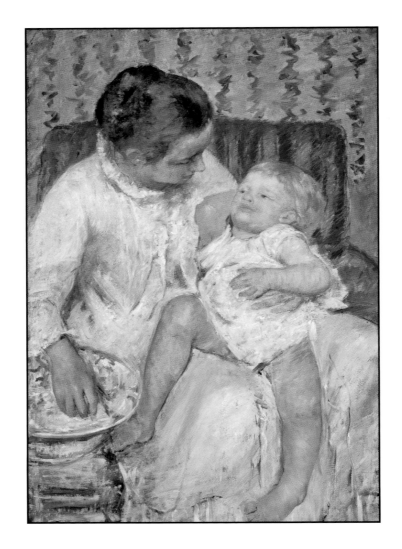

*Mother About to Wash
Her Sleepy Child*
1880
Oil on canvas
100.33 × 65.72 cm
Los Angeles County
Museum of Art,
Los Angeles, California

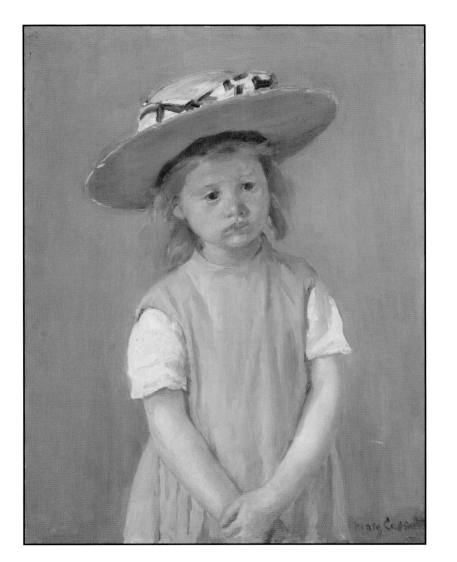

Child in a Straw Hat
1866
Oil on canvas
65.3 x 49.2 cm
National Gallery of Art,
Washington, DC

Paul Gauguin

1848 to 1903
French, lived in France and French Polynesia

Interesting Fact: *Paul Gauguin worked for two weeks as a laborer to build the Panama Canal. The Panama Canal is a manmade waterway that connects the Pacific and Atlantic Oceans through the very narrow strip of land that is the country of Panama in Central America. Central America connects North and South America.*

Self-portrait of the artist around the age of 45

Paul Gauguin was born in France. His mother was from Peru, a country in South America. When he was a child he lived in Lima, Peru. (Although Lima looks like the word for lima bean, you don't say it the same way. It is pronounced Lee-ma.) Gauguin did not grow up planning to be an artist. First, he was a sailor, then, he was a banker. While he was working in the bank, he started to paint for fun. He was an amateur artist. Gauguin also sculpted, carved objects from wood, and made ceramics. Soon, he became a full-time artist. Although he painted many scenes of France, where he lived with his family, he also visited exotic tropical islands. Eventually, he moved to Tahiti in the middle of the big, blue Pacific Ocean, and he painted the native people who lived on the island. Gauguin loved bright colors. He knew many of the Impressionist painters, but he was not an Impressionist. He brought a new, modern style called Symbolism to art. In *Still Life with Three Puppies*, can you count three apples? How about three goblets (a type of drinking glass)?

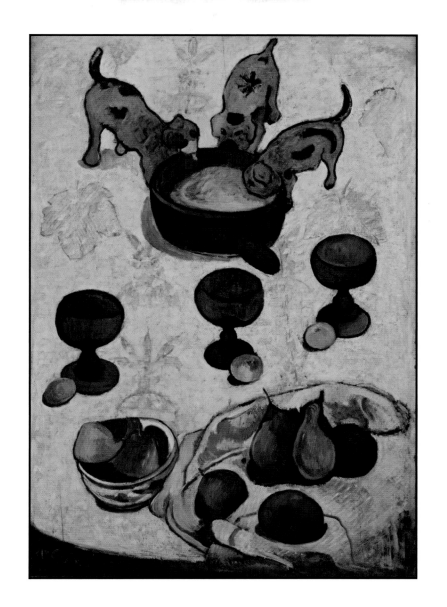

Still Life with Three Puppies
1888
Oil on wood
91.8 x 62.6 cm
Museum of Modern Art,
New York, New York

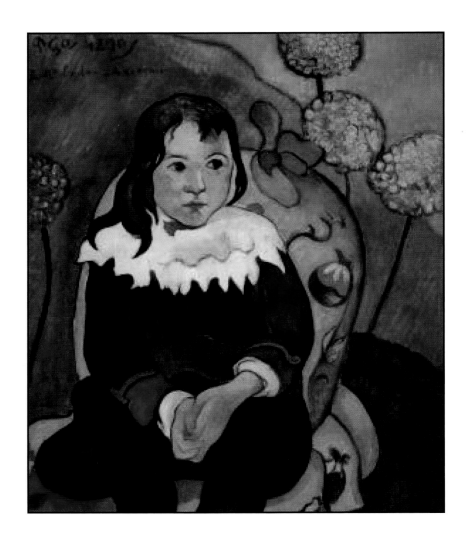

Mr. Lou Lou
(Louis Le Ray)
1890
Oil on canvas
55.2 x 46.4 cm
The Barnes Foundation,
Philadelphia, Pennsylvania

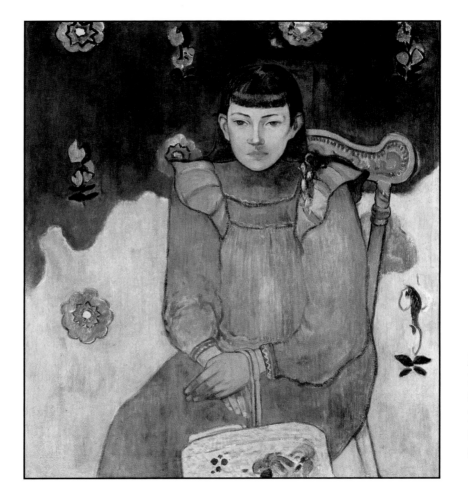

Portrait of a Young Woman
1896
Oil on canvas
75 x 65 cm
Ordrupgaard,
Copenhagen, Denmark

Eva Gonzalès

1849 to 1883
French, lived in France

Interesting Fact: *Eva Gonzalès' first art teacher was named Charlie Chaplin—the very same name as a famous and funny actor in movies so old that they did not have sound! They were called silent movies. At the movie theater, someone played piano or organ music that was fast then slow, loud then soft, to go with the action of the movie.*

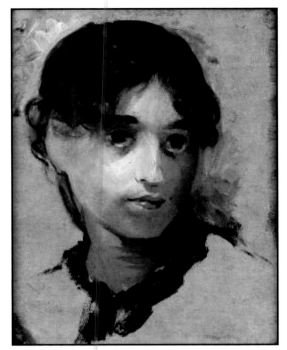

Self-portrait of the artist, date unknown

When she was 16 years old, Eva Gonzalès began to study drawing and painting. Her parents thought it was a very good idea. Her father was a writer and her mother was a musician. She later became the pupil of Edouard Manet. In fact, she was the only formal art pupil he ever accepted. She also modeled for him. She painted in the Impressionist style, like Manet, and like Manet, she never exhibited her paintings at any of the Impressionists' exhibitions. Sadly, Eva Gonzalès died after the birth of her baby boy, Jean, when she was only 35 years old. Because she did not live very long, she was not able to create as many paintings as other artists. Her favorite subjects, just like the other two women who painted in the Impressionist style (Mary Cassatt and Berthe Morisot) were women and children. The painting on the opposite page is called *Nanny and Child*. Look back at Manet's painting *The Railway*. How are the paintings alike? How are they different? Art experts believe that the painting by Gonzalès is a tribute to her teacher, Manet.

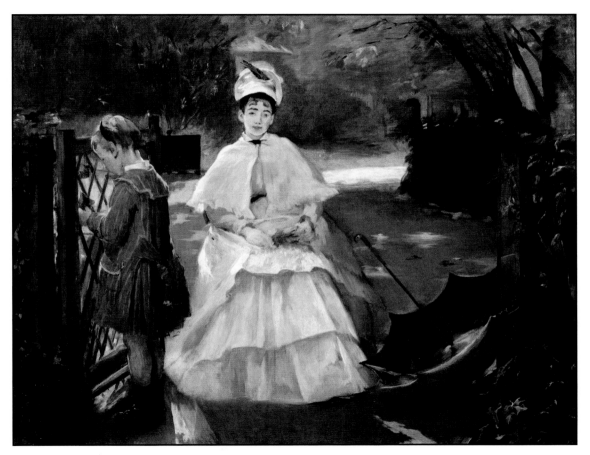

Nanny and Baby
1877–78
Oil on canvas
65 x 81.4 cm
National Gallery of Art,
Washington, DC

La Toilette
1879
Oil on canvas
Dimensions unknown
Private Collection

Lady with a Fan
c. 1869–70
Pastel
42.5 x 27 cm
Minneapolis Institute
of Arts, Minneapolis,
Minnesota

Vincent van Gogh

1853 to 1890
Dutch, lived in France

Interesting Fact: *Before he became an artist, Vincent van Gogh worked in an art gallery in London. He could speak English, French, German, and Dutch, all quite well. Then he decided to be a preacher like his father. He preached to coal miners and was called by them "Christ of the Coal Mines." Soon, however, he was called to art.*

Self-portrait of the artist
at the age of 34

Vincent van Gogh taught himself how to draw and paint. First, he made black-and-white drawings, then, he made watercolor paintings on paper, and lastly, he began to create oil paintings on canvas. Van Gogh admired the landscape paintings of François Millet (you may already have read about him in this book), so he painted landscapes—orchards, fields, and trees—too. Soon, van Gogh moved to France, leaving his home in the Netherlands. In France he saw the paintings of the Impressionists and began to experiment with their style and techniques. Like their paintings, his paintings had bright colors and brushstrokes that are easy to see. Van Gogh worked very quickly. He could paint a picture in one or two days. His brother, Theo, was an art dealer. Theo sold the paintings of his brother Vincent and other artists to art collectors. It is good for artists to sell their paintings. They can use the money to buy paints, brushes, and canvases to make more paintings. But just because artists cannot sell their paintings does not mean they are bad artists. Many of the artists in this book were not able to sell their paintings, but today they are very famous.

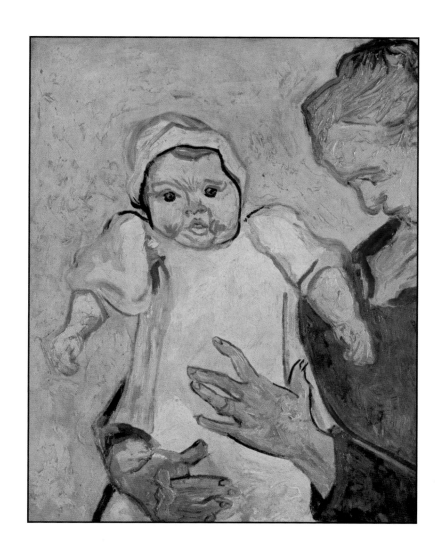

*Madame Roulin and
Her Baby*
1888
Oil on canvas
63.5 x 51.1 cm
The Metropolitan
Museum of Art,
New York, New York

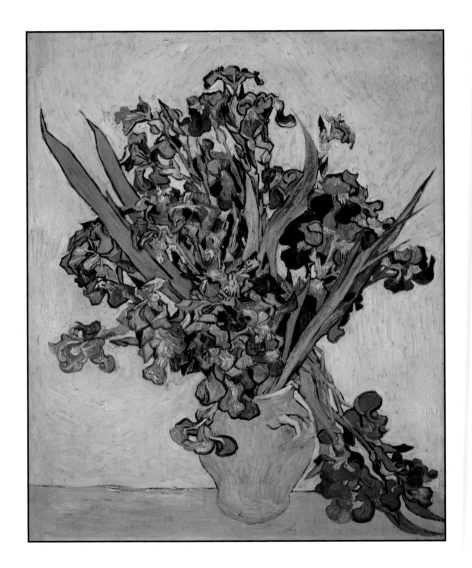

Irises
1890
Oil on canvas
92 x 73.5 cm
Van Gogh Museum,
Amsterdam,
The Netherlands

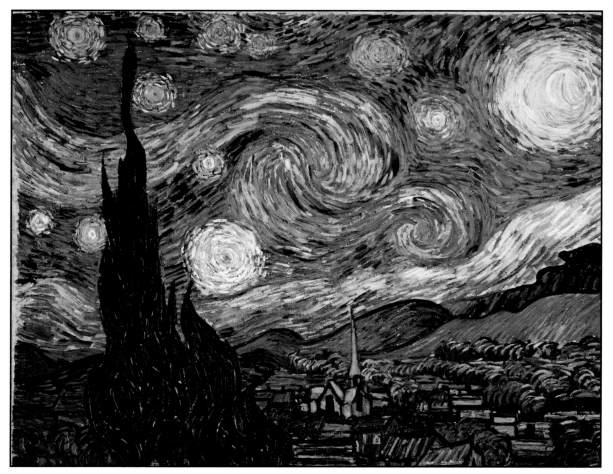

The Starry Night
1889
Oil on canvas
73.7 x 92.1 cm
Museum of Modern Art,
New York, New York

John Singer Sargent

1856 to 1925

American, lived in Europe

Interesting Fact: *John Singer Sargent, an American born in Italy, did not visit America until he was 20 years old. On his first trip to America, he saw Niagara Falls.*

Although he was born in Florence, Italy, John Singer Sargent was an American because his parents were from America. While he was growing up, he and his parents moved from one city to another among the countries in Europe. Sargent did not attend school like most children do. Instead, he learned by visiting museums and ancient cities and learning to speak the languages of the countries that he lived in. He played the piano well. His mother was an amateur artist and showed him the basics of drawing. Soon, he was off to Paris, France, the center of the art world at that time so he could formally study art. Portraits are what Sargent is best known for. He received many commissions for portraits. That means he was paid to paint the portrait. Dolly (11 years old, on the left) and Polly (7 years old, on the right), the Barnard sisters, were the models for Sargent's painting *Carnation, Lily, Lily, Rose* on the opposite page. They are playing (very carefully!) with Chinese lanterns and are surrounded by lilies. On the next page are two portraits. The little girl is 3-year-old Ruth. She is holding her doll and wearing rainboots.

Self-portrait of the artist
at the age of 50

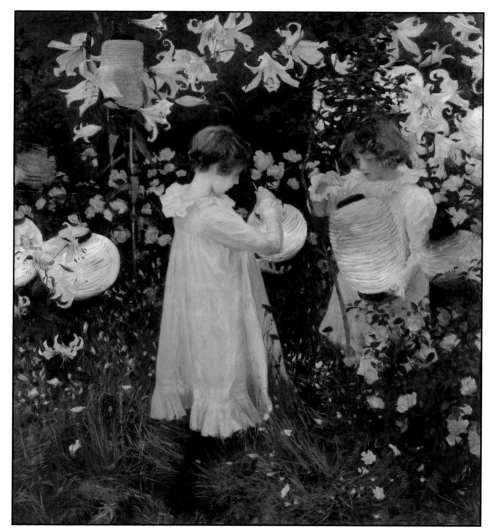

Carnation, Lily, Lily, Rose
1873
Oil on canvas
174 x 153.7 cm
Tate Britain,
London, England

John Singer Sargent

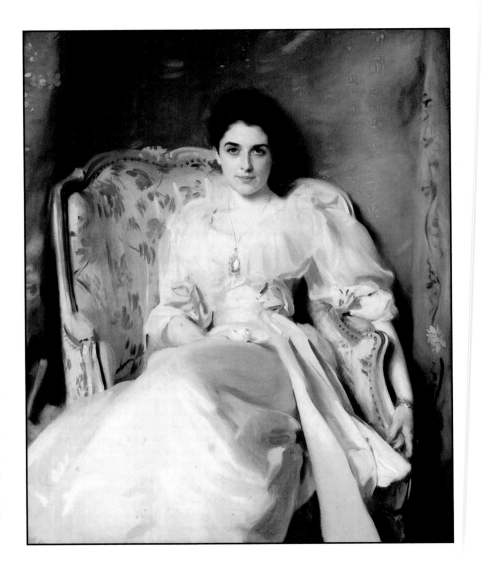

Lady Agnew of Lochnaw
1893
Oil on canvas
124.5 x 99.7 cm
National Galleries
of Scotland,
Edinburgh, Scotland

102

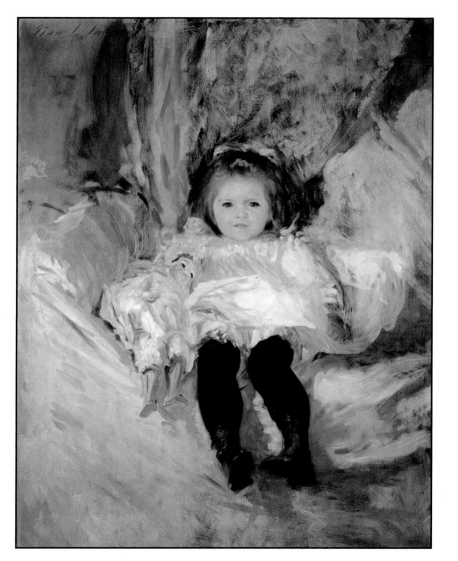

Ruth Sears Bacon
1887
Oil on canvas
123.8 x 92.1 cm
Wadsworth Atheneum
Museum of Art,
Hartford, Connecticut

Georges Seurat

1859 to 1891
French, lived in France

Interesting Fact: A Sunday on La Grand Jatte *is the inspiration (idea) for the Broadway musical* Sunday in the Park with George. *Watching the musical is like seeing the painting come to life! You can watch* Sunday in the Park with George *on the Internet. George is, of course, Georges Seurat. In English, George does not end with "s".*

Pointillism, or Neo-Impressionism, is the style of painting that Georges Seurat is known for. Seurat, and other Neo-Impressionists such as Paul Signac, studied how science and the study of optics (light) affected the colors they used in their paintings. They believed that dots, or points, of color placed very close together gave their paintings more vibrancy (liveliness) than when the colors were smoothly blended. Notice that when you look at the paintings by Seurat in this book, the dots of color merge (combine) to make a picture. If you see the paintings in a museum, and get very close to them (but remember never to touch them), you will see the individual dots of color. Can you see the painted border of red, orange, and blue dots around *A Sunday on La Grande Jatte*? La Grande Jatte is a park on the Seine River that runs through the middle of Paris, France. Seurat worked on this painting for several years and added the border just before he finally finished it. *The Circus* and *Cancan* also have painted borders. Both of these paintings show how Parisians had fun. Have you been to the circus? Have you danced the cancan?

Portrait of the artist at the age of 50 painted by Ernest-Joseph Laurent

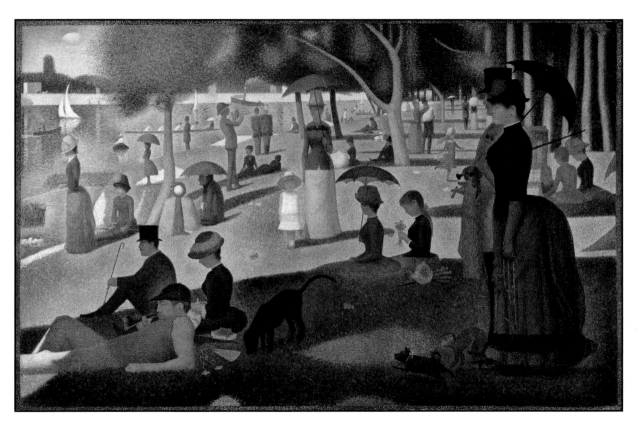

*A Sunday on
La Grande Jatte–1884*
1889–90
Oil on canvas
207.5 x 308.1 cm
The Art Institute
of Chicago,
Chicago, Illinois

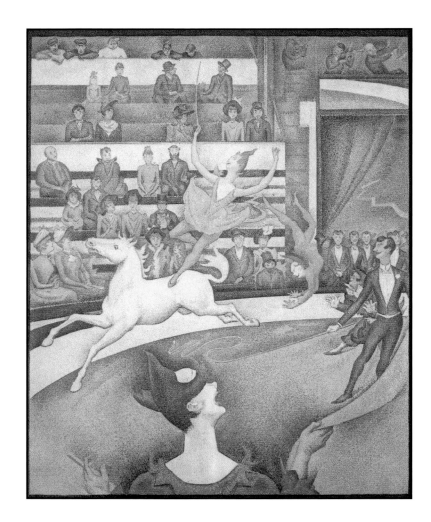

The Circus
1889–90
Oil on canvas
185 x 152 cm
Musée d'Orsay,
Paris, France

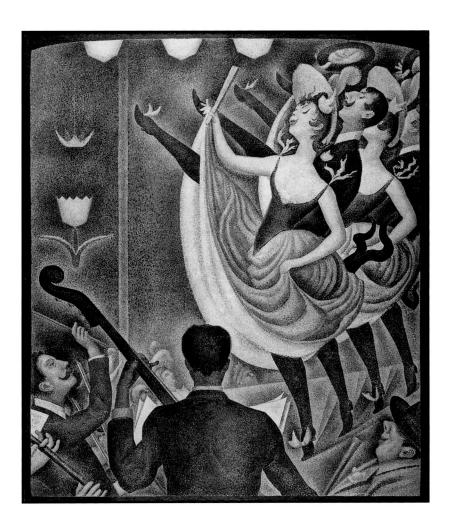

Cancan
1889–90
Oil on canvas
169 x 141 cm
Rijksmuseum Kröller-Müller,
Otterlo, The Netherlands

Alphonse Mucha

1860 to 1939

Czech, lived in Czechoslovakia (now Czech Republic), France, and America

Interesting Fact: *Alphonse Mucha drew pictures even before he could walk. His mother tied a pencil around his neck so he could draw while he crawled on the floor.*

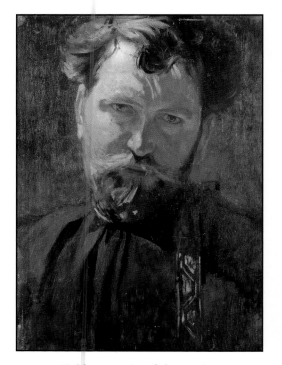

Self-portrait of the artist
at the age of 39

Alphonse Mucha's big break came while he was working at a printing office over a holiday when all the artists who normally worked there were on vacation. Sarah Bernhardt, a very famous actress in Paris, France, needed a poster to advertise (tell people about) her play *Gismonda*. Mucha was the only artist in the office, so he got the job. His design was revolutionary! It was called art nouveau, or new art. Many of his artworks were for theater posters, magazine covers, postcards, and calendars. He also created designs for jewelry, plates, and fabrics. *Feather* and *Primrose*, *Rêverie*, and *Fruit* are all posters made in Mucha's art nouveau style. But the major work of his career, called *Slav Epic*, is very different from his art nouveau style. An epic is an exciting story. *Slav Epic* shows the history of the Slav people, who are Mucha's ancestors, from many thousands of years ago until the time that Mucha lived, almost 100 years ago. It is made up of 20 very large paintings. Each panel (painting) tells a part of the story. Mucha gave this great work to the city of Prague, the capitol city of the Czech Republic. If you visit Prague, you can see it and learn the history of the Slav people.

Feather (left)
Primrose (right)
1899
Color lithograph posters
71 x 27.3 cm
Mucha Museum,
Prague, Czech Republic

Rêverie
1897
Color lithograph
72.7 x 55.2 cm
Mucha Museum,
Prague, Czech Republic

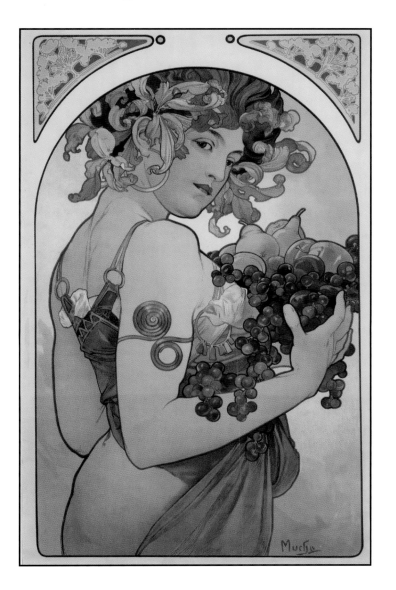

Fruit
1897
Color lithograph
66.2 x 44.4 cm
Mucha Museum,
Prague, Czech Republic

Gustav Klimt

1862 to 1918
Austrian, lived in Austria

Interesting Fact: *Even after he was an accomplished artist, Gustav Klimt practiced his drawing skills every day.*

Photograph of the artist, date unknown

When Gustav Klimt began studying at the art high school, he wanted to be a drawing teacher. His brother Ernst also studied there. But it wasn't long before he and his brother, along with an artist friend, formed an art business. Right away they were hired to paint murals on the walls and ceilings of many important buildings, such as theaters and museums, in Austria, Germany, and Switzerland. Soon, Klimt began to create his own style with bright colors, symbols, and a lot of glittery gold. His favorite subjects were people (figures), especially women, although he did paint a series of seaside landscapes (seascapes!) in the latter part of his career. On a trip to the cities of Venice and Ravenna in Italy, he saw mosaics for the first time. A mosaic is a picture made from many small pieces of colored stone, marble, or glass. These mosaics were decorated with real, shiny gold. The paintings Klimt made after his trip to Italy look almost like mosaics. He added real gold and silver leaf (very thin pieces of gold and silver) to his paintings. This is called his "golden period." The portrait of Adele Bloch-Bauer on the next page is a perfect example of Klimt's "golden style."

Baby (Cradle)
1917–18
Oil on canvas
110.9 x 110.4 cm
National Gallery of Art,
Washington DC

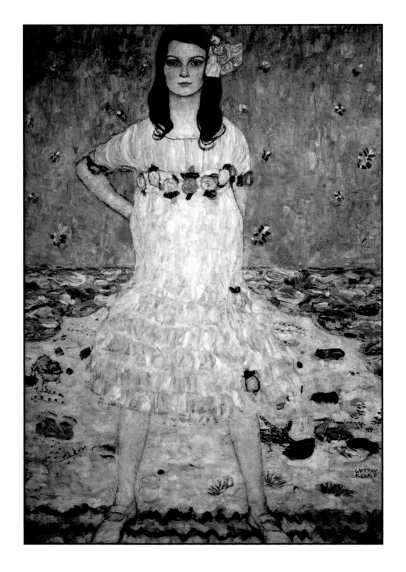

Mäda Primavesi
1912
Oil on canvas
149.9 x 110.5 cm
The Metropolitan
Museum of Art,
New York, New York

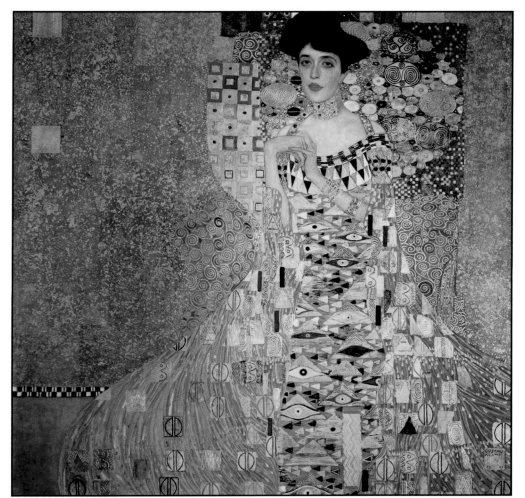

Adele Bloch-Bauer
1907
Oil, silver, gold on canvas
140 x 140 cm
Neue Galerie,
New York, New York

Edvard Munch

1863 to 1944

Norwegian, lived in France, Germany, and Norway

Interesting Fact: *Edvard Munch painted murals for the workers' dining room of a chocolate factory in his hometown of Oslo, Norway. A mural is a picture painted on a wall or ceiling. It is usually very big.*

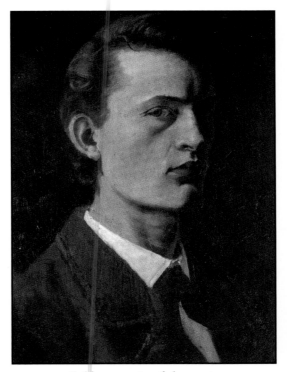

Self-portrait of the artist
at the age of 19

Edvard Munch was born in Norway, a country in northern Europe known for its fjords (long, narrow ocean inlets with steep sides or cliffs) all along its rocky coast. It also has lots of snow in winter. Summer days are very long and winter days are very short. On the summer solstice in June (the longest day of the year), the sun is still up at midnight! As a child, Edvard was sickly and often not able to go to school. To entertain himself, he began to draw and paint. He worked hard and was given a scholarship to study painting in Paris, France, where he met the artists Vincent van Gogh and Paul Gauguin. Edvard liked their use of bright colors. *Summer Night's Dream* is one of 22 paintings that make up *The Frieze of Life*, one of Edvard's most famous works. Do you think the light on the water in *Summer Night's Dream* is the sun or the moon? A frieze is a long stretch of painting or sculpture on a wall. It is made up of different scenes. Each scene tells a part of the story. On the next page, *Four Girls in Årsgårdstrand* is a painting of neighborhood girls from the Norwegian coastal village where Munch visited in the summer.

*Summer Night's Dream
(The Voice)*
1893
Oil on canvas
87.9 x 108 cm
Museum of Fine
Arts Boston,
Boston, Massachusetts

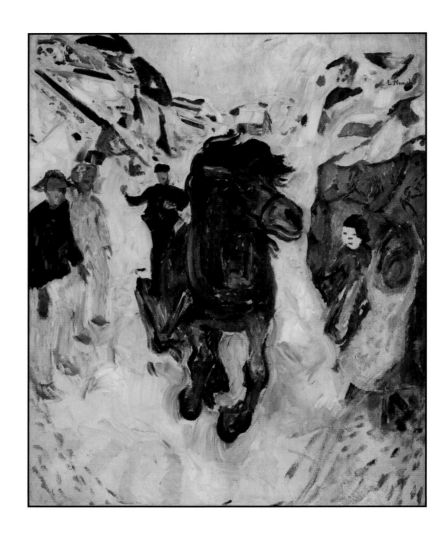

Galloping Horse
1910–12
Oil on canvas
148 x 120 cm
The Munch Museum,
Oslo, Norway

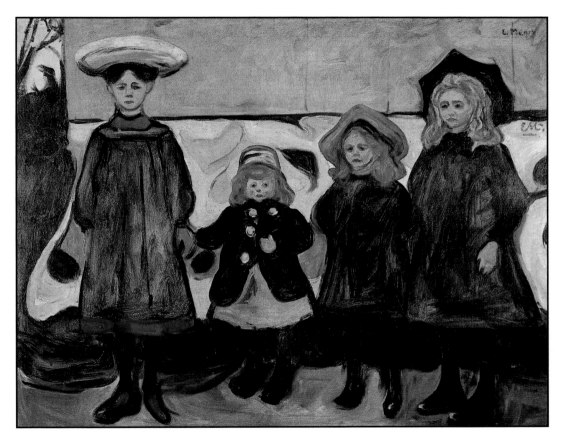

Four Girls in Årsgårdstrand
1903
Oil on canvas
87 x 111 cm
The Munch Museum,
Oslo, Norway

Amedeo Modigliani
1884 to 1920
Italian, lived in France

Interesting Fact: *Amedeo Modigliani's birth saved his family from great loss. Modigliani's father had fallen on hard times. He could not pay his debts. The family was in danger of losing their possessions. But according to Italian law, no one could take away the bed of a new mother. His mother was sleeping with her new son, Amadeo, and the family piled all of their valuable belongings on the bed with them. All was saved.*

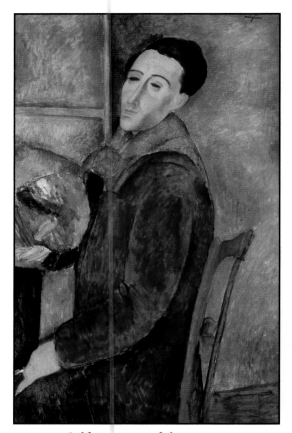

Self-portrait of the artist
at the age of 34

Amedeo Modigliani began to paint when he was 15 years old. Soon he was on his way to Venice, Italy, and later to Paris, France, to make his living as an artist. In Paris he began to study sculpture and to create his own sculptures. A sculpture is a three-dimensional piece of art. Often it is a figure or animal that is carved out of a piece of stone or wood. Modigliani studied African sculpture, which has figures that are simple, tall, and thin. He gave the men, women, and children in his paintings the same long faces, arms, legs, and torsos (bodies) that he saw in African sculpture. At an exhibition of young artists in Paris in 1912 (more than 100 years ago), he showed eight stone heads that he had sculpted. But Modigliani soon lost interest in sculpting and returned to painting. How would you describe the girls in Modigliani's paintings? Are they quiet or busy, happy or sad? How are they different from the girls in John Singer Sargent's paintings? How are they alike?

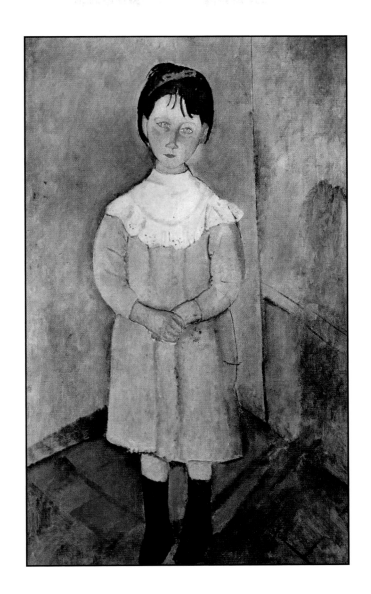

Little Girl in Blue
1918
Oil on canvas
116 x 73 cm
Private Collection

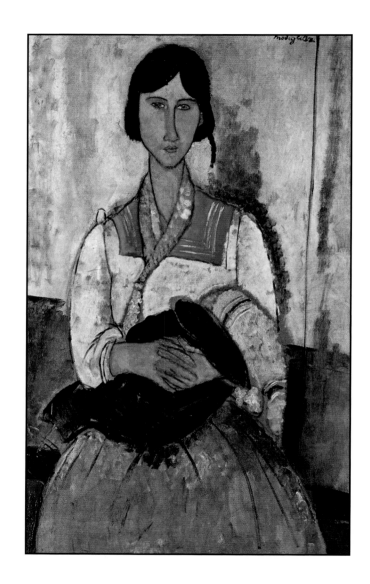

*Gypsy Woman
with a Baby*
1919
Oil on canvas
115.9 x 73 cm
National Gallery of Art,
Washington, DC

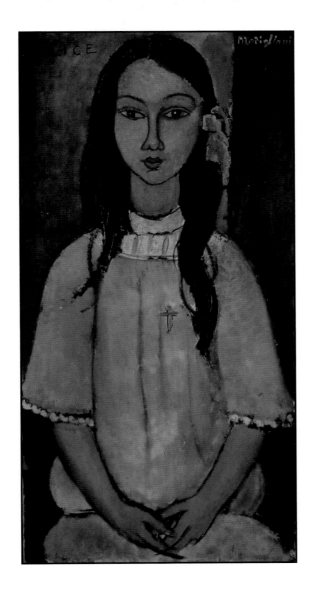

Alice
c. 1918
Oil on canvas
39 x 78 cm
National Gallery
of Denmark,
Copenhagen, Denmark

Paul Klee

1879 to 1940
German and Swiss, lived in Germany

Interesting Fact: *Paul Klee (pronounced like "clay") studied the violin as a child. He was so good at playing the violin he was asked to play with the Bern Music Association when he was only 11 years old. Bern is the capitol city of Switzerland, the city where Klee lived when he was growing up.*

Photograph of the artist
at the age of 32

Paul Klee is known for his abstract style of painting. Abstract means that the picture represents a thought or idea and may not look like anything we know in real life. Klee was one of several famous abstract artists. Have you heard of Wassily Kandinsy, Franz Marc, Pablo Picasso, or Georges Braque? You may want to look for books in the library or on the Internet to find pictures that they painted. Klee took a trip to Tunisia, a country in North Africa. He thought the sunlight there made colors look very special. After his trip to Tunisia, he could not forget the colors he had seen there. He used those special colors and symbols to describe the music or poetry twirling around in his head. From then on, the subjects of his paintings came only from his imagination. He painted on many different surfaces. Cardboard, paper, burlap, and canvas. The titles (names) he gave his paintings were very important to him. What story can you make up about *Cat and Bird*? How many fish are in *Fish Magic*? What other things do you see in the painting? Can you point to a circle, square, rectangle, and triangle in the *Red Balloon*?

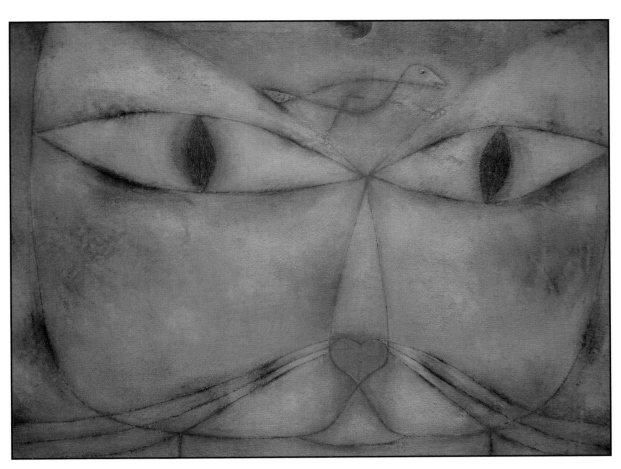

Cat and Bird
1928
Oil and ink on gessoed
canvas, mounted on wood
38.1 x 53.2 cm
Museum of Modern Art,
New York, New York

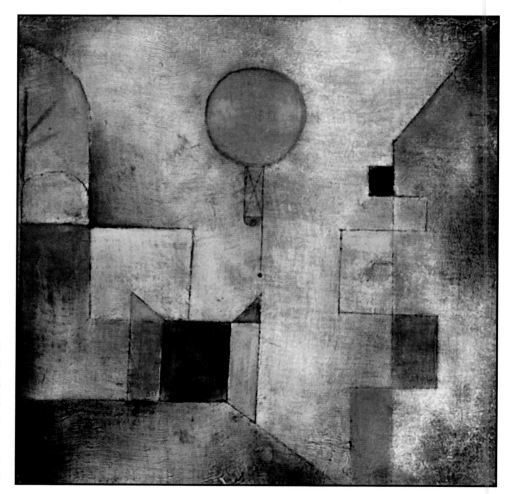

Red Balloon
1922
Oil on chalk-primed
gauze, mounted on board
31.7 × 31.1 cm
Solomon R. Guggenheim
Museum,
New York, New York

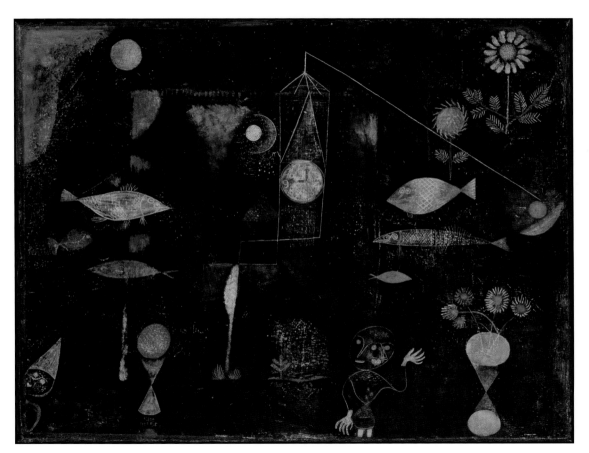

Fish Magic
1925
Oil and watercolor on
canvas on panel
77.1 x 98.4 cm
Philadelphia Museum of Art,
Philadelphia, Pennsylvania

The End As Beginning

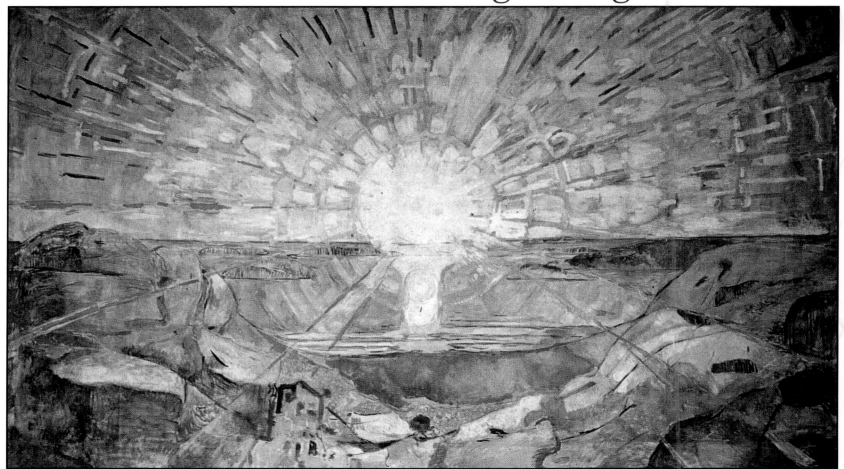

The Sun, Edvard Munch, 1916, Oil on canvas, 455 x 780 cm, The University of Oslo, Oslo, Norway